CREATIVE
NATURE &
OUTDOOR
PHOTOGRAPHY

BRENDA THARP

AMPHOTO BOOKS

AN IMPRINT OF WATSON-GUPTILL PUBLICATIONS / NEW YORK

To my parents, who shared with me their love of the great outdoors, and especially to Dad, for giving me my first camera and starting all of this.

Library of Congress Control Number: 2002116959

ISBN-13: 0-8174-3738-1

ISBN: 0-8174-3738-X

Typeface: Garamond 3

Senior Acquisitions Editor: Victoria Craven
Editor: Stephen Brewer
Designer: Barbara Balch
Production Manager: Ellen Greene

Printed in Spain

First printing, 2003

3 4 5 6 7 / 07 06

ACKNOWLEDGMENTS

I'd like to thank Victoria Craven for seeing the potential of my idea and commissioning this book. Many thanks also to Stephen Brewer, Patricia Fogarty, and Barbara Balch for their creative effort in producing this book. My genuine thanks go to Sam Abell, the instructor for my first "serious" photo workshop, a turning point in my life. For giving me guidance and challenging me to grow, I also thank many photographers associated with the *National Geographic,* from whom I learned so much during various workshops. For teaching me the value of personal vision, and giving me encouragement early on, I am forever indebted to photographer Dewitt Jones.

My profound thanks go to Reid Callanan, director of the Santa Fe Photographic Workshops, who gave me my first break at teaching on a national level. He was soon followed by David Lyman of the Maine Photographic Workshops, and Neil and Jeanne Chaput de Saintonge of the Rocky Mountain School of Photography. I am grateful to them for the continuing opportunity to teach. I also extend my gratitude to past workshop students; you've opened my eyes as I hope I've opened yours. Special thanks to all the photo editors that send me to wonderful places and to editors Jen Bidner, Bill Hurter, Peter Burian, and Rob Sheppard for publishing my articles over the years. Many thanks also to Dave Metz of Canon for his continued support.

My deepest gratitude goes to Jed Manwaring, my partner, for his loving support and generous help in preparing this book; also to David Bathgate, Alan Babbitt, and Amy Campbell, for their encouragement; and to my sisters Doretta, Sharon, and Marlene, and their families, for their unshakable belief in me. I owe you more than words can say.

CONTENTS

Introduction 6

1 LEARNING TO SEE *12*

2 LIGHT: THE ESSENTIAL ELEMENT *16*

3 VISUAL DESIGN *44*

4 THE DYNAMIC IMAGE *62*

5 CREATING EFFECTIVE COMPOSITIONS *76*

6 WORKING WITH COLOR *98*

7 EXPRESSIVE TECHNIQUES *106*

8 ARTISTIC INTERPRETATIONS *126*

9 EXERCISING YOUR VISION *136*

10 EVALUATING YOUR PROGRESS *140*

11 A DEEPER VIEW *144*

Tools and Resources *158*

Index *160*

INTRODUCTION

The only limits are, as always, those of vision.
—JAMES BROUGHTON

"What are you trying to say with this photograph?" Someone asked me this question many years ago at a photography workshop, and it is still the driving force behind my photography. The question hovers in my subconscious with every image I pursue, and it influences every action I take to create a photograph. To me, "What are you trying to say with this photograph?" is the most fundamental of all questions regarding creative photography.

Nature and outdoor photographers want to share the beauty of a landscape, the drama of light, and the action of wildlife. Travel photographers want to share the faces of a culture, a slice of daily life, and a sense of place. Photojournalists want to share the moment or emotional situation before them. We're really all after the same thing: to create images that express what we see, feel, and experience in the world around us. Whether we are aiming for artistic interpretation or realism, the common goal is to make our photographs as creative and expressive as possible.

Why then, do so many images fail to convey what the photographer really saw or experienced? They are side-of-the-road or edge-of-the-crowd snapshots, static records of what was seen. Those photographs don't move us—they don't invite us in to explore the visual scene or to experience the moment. Usually, the photographer approached the scene as a removed observer. No matter what you are photographing, if you are not feeling connected with what you are seeing, viewers won't connect with the final picture. When you aren't clear about what you want to say with the photograph, the resulting visual message may say nothing. At best, it may only communicate the facts in a less-than-exciting way.

GLACIAL ABSTRACT, ALASKA. Canon EOS-1N, 80–200mm lens, Fujichrome Provia 100F.

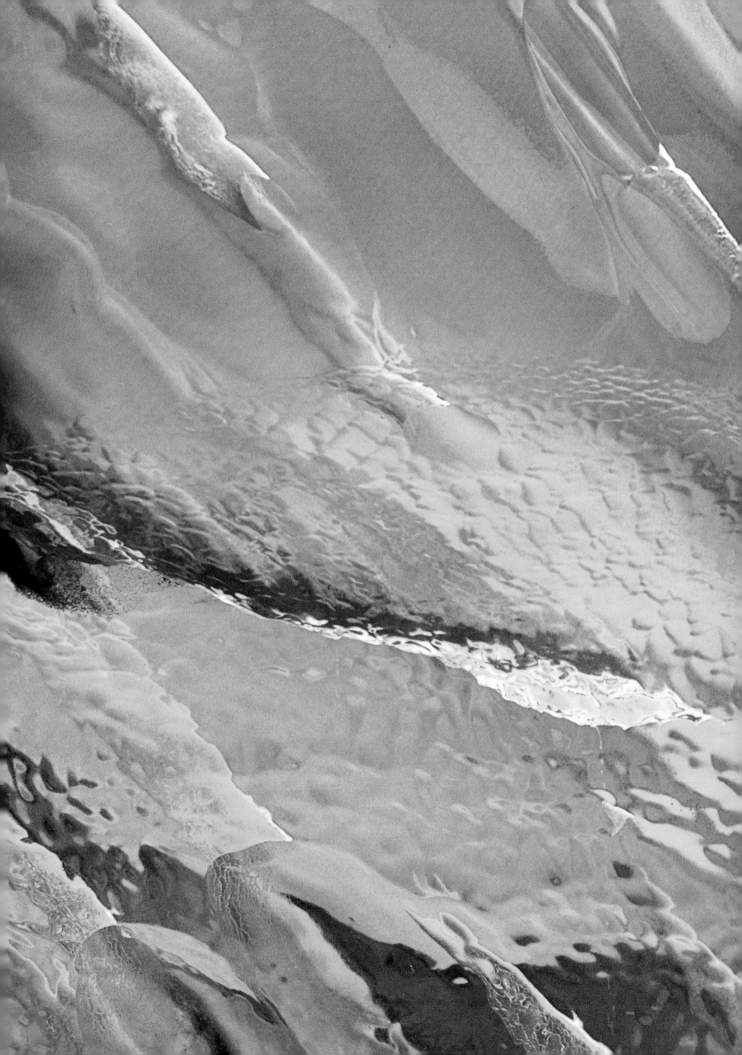

If you want to photograph more creatively, you'll need to begin looking at the world differently. Engage the great outdoors with a sense of awe and wonder. Crawl on your belly in meadows and climb mountains to new heights; touch the trees; smell the flowers; feel the wind. When you make photographs from the perspective of your experiences, your photographs will be much more compelling.

Ansel Adams once said, "We don't make a photograph just with a camera; we bring to the act of photography all the books we have read, the movies we have seen, the music we have heard, the people we have loved." If you view life through the filters of your experiences, you'll see the world uniquely. If you want to make positive, awe-inspiring images, decide now that you'll have as many awe-inspiring experiences as possible. Look at the world through the filters of awe and wonder, and you'll see many great things. Then draw from your own creative well of experiences when you make your photographs.

As a child, I spent a lot of time outdoors with my family. We hunted for fossils in Pennsylvania and canoed the Delaware River. We hiked Mount Washington in New Hampshire, picked wild blueberries in New York, and played at the Jersey shore. I developed a love for the outdoors and a respect for the fragile beauty of my world. Those experiences created the filters through which I viewed the world and built the foundation of my passion: to share that view through my photographs.

Yet even with a deep connection to the outdoors, my early pictures were horrible interpretations of what I saw! For all the passion I had, I lacked the technical understanding of how to get my vision onto film. My understanding of design, perspective, and color were also very rudimentary. Determined to change that, I began attending workshops. My photographs quickly became better technically, yet there was still something missing in many of them. Searching for some magical technique, I enrolled in a workshop with Sam Abell, a *National Geographic* photographer and a now-legendary instructor. When Sam reviewed my portfolio, he said "These are nothing more than postcards; they don't communicate the real experience of being there."

Ouch! Thinking back on it, the photographs were pretty mundane. Sam challenged my "bystander approach" and encouraged me to become more involved in the photograph. I learned a valuable lesson that week: In those pictures, *I* was missing. After that epiphany, I ended the week with some very good pictures. I continued to photograph after the workshop, but the results were inconsistent—my photos were either great or pretty bad! I hadn't quite broken the old habits, so I enrolled in more workshops, studied books on art and photography, and made many more photographs. I learned how to use the tools—cameras, lenses, and flashes—to put my vision on film. More important, I learned about the art of seeing and how my feelings about a subject affected my vision of it.

This book addresses aesthetic rather than technical aspects of photography, and therefore it isn't really a beginner's book. However, even a

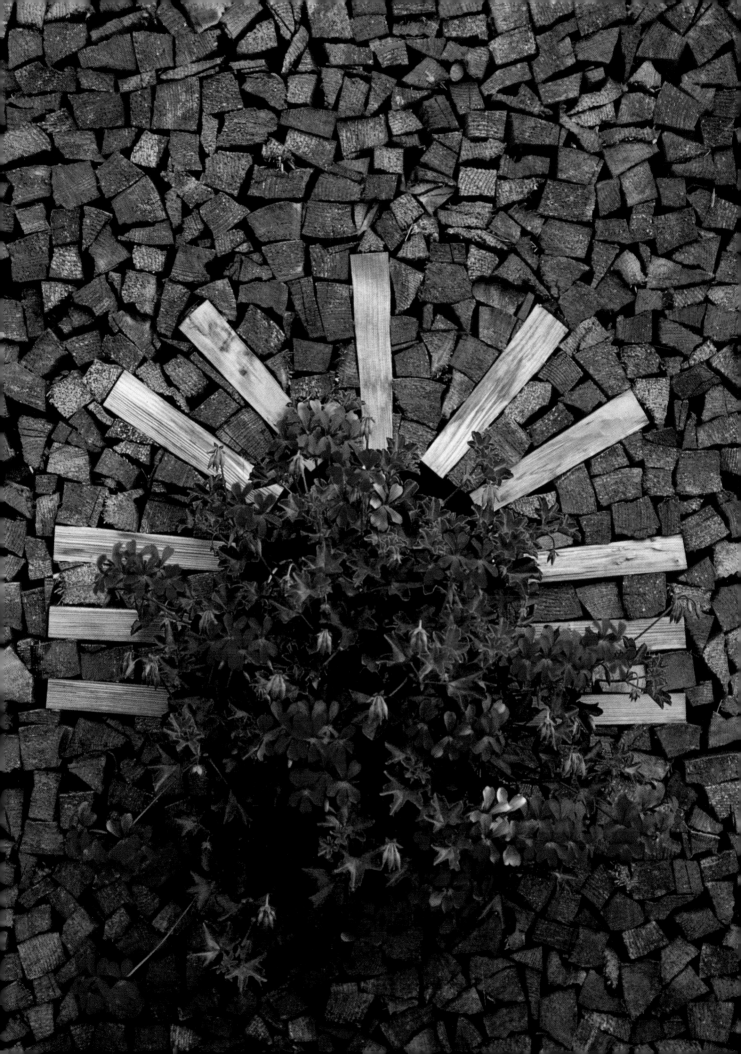

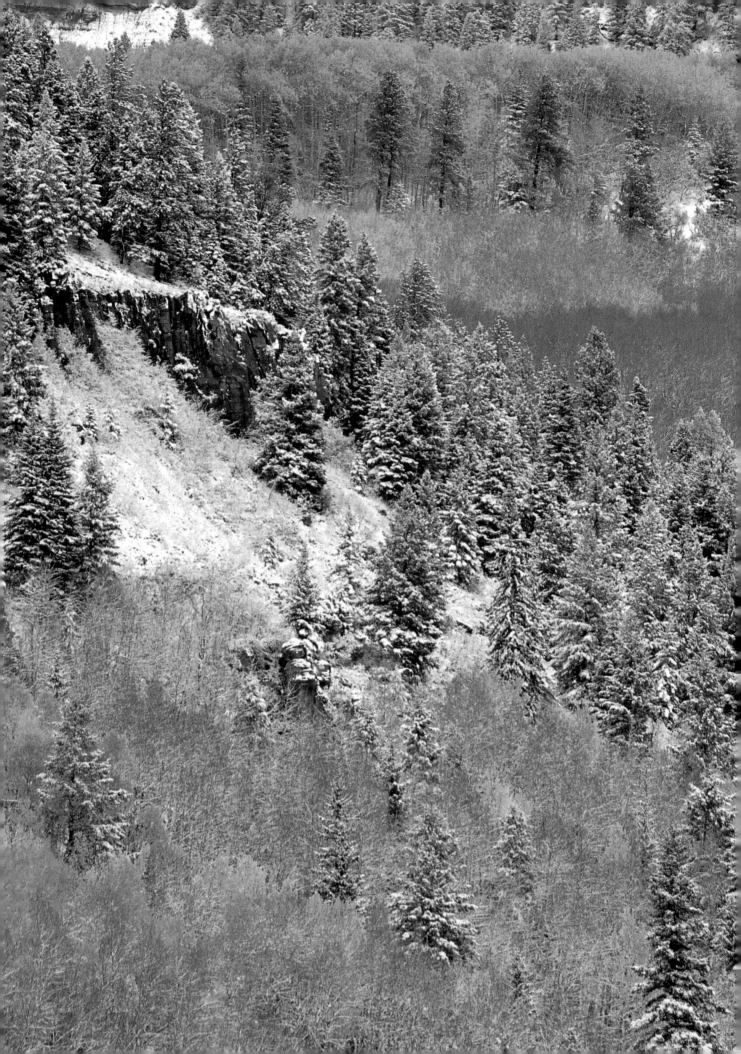

beginning photographer can learn the aesthetic before mastering the technical. Because art and technique overlap, I do discuss some essentials of the craft—light, perspective, and composition—and how they relate to making expressive outdoor images. However, the chapter on composition is not just about proper placement of your subject, but a discussion of the other key elements: dominance, balance, and proportion.

The goal of the book is to teach you how to use light, design, composition, and creative techniques to make photographs that go beyond the ordinary. Along with those fundamental topics, you'll also learn how to use motion, mood, and color to make your images more expressive. Finally, you'll discover what it means to capture the essence of your subject and ways to create an abstract photograph.

The text, along with the visual exercises, will help you develop your own creativity, but the book requires some effort. Read the section on design and learn how shapes, patterns, and lines enhance your photographs, then go out and find those design elements. Study the sections on perspective and composition, and apply these ideas to create unique viewpoints and make uncluttered visual statements. The concepts in this book can make

a profound difference in your photography, but success lies in their application.

You may be asking if it's possible to learn to see more creatively. The answer is a resounding "Yes." Creativity is nothing more than a combination of inspiration, visual perception, and imagination, along with some technical skill. You can learn how to discover all of these qualities within yourself. All it takes is a little effort to learn the ideas covered in this book, a willingness to ask, "What if?" and the courage to act on your curiosity. Always remember that while craft and art are important, it is the creative vision that makes the difference between an ordinary shot and a great photograph. This realization alone will push you into the realm of the creative photograph.

It is my sincere hope that this book will provide you with the tools you need to develop your vision and that it will serve as a guide in your discovery of personal creativity. The information I provide here is the foundation and springboard for your experimentation. Step up to the line and be willing to participate in the learning process by reading and doing the exercises. Open your mind, your eyes, and your soul to what's around you, and share what you see through your photographs.

Facing page: CHAMA VALLEY, NORTHERN NEW MEXICO. Canon EOS-1N, 80–200mm lens, Fujichrome Velvia.

LEARNING
TO SEE

*The real voyage of discovery consists not in seeking new landscapes
but in having new eyes.* —MARCEL PROUST

The success of any photograph relies upon these key ingredients: great light, a dynamic composition, good visual design, and an interesting moment. I don't always succeed in getting all of them in one picture, but when I do it's exhilarating. This accomplishment motivates me to keep honing my vision, my sense of design, and my reflexes.

The success of a photograph depends entirely upon the photographer. You decide whether the light is right for your subject and whether it is interesting. You select the point of view, design the composition, and choose the appropriate camera settings. Before you do anything, however, you must intuitively answer the question, "What do I find interesting about the scene or subject?" It is not enough to say, "I like the trees." Why do you like the trees? Maybe you love their pattern or how the light creates tree shadows on the hillside. Whatever the reason, in precisely identifying what you find interesting you clarify your vision, a key part of the formula for making memorable images.

Equally important is articulating how you feel about your subject, or what it means to you. One day while walking on a beach, I looked at bubbles from the sea foam very closely, drawn to the prismatic colors reflecting off their surface. They reminded me of tiny jewels, baubles of colorful light. When I decided to photograph them, the sharply focused image made all the other elements stand out too much. I threw caution and technical rules to the wind and put the entire scene out of focus. Voilá! Now the baubles of color stood out. Does it matter that this image is out of

UNTITLED. Canon A2, 100mm macro lens, Kodak E100S.

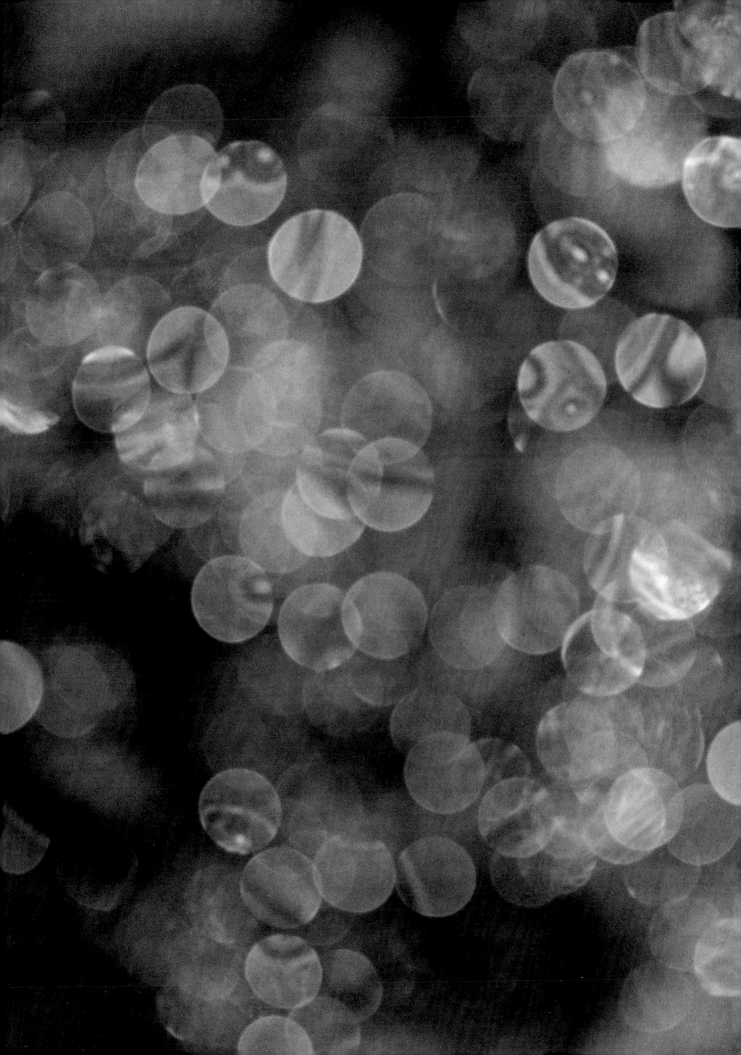

focus? No, because as a friend once said, "It's art, man!" And art is your own interpretation of reality.

Once you've identified what interests you and how you feel about it, you have the basis for all the actions and decisions you'll make to create the photograph. You'll choose the equipment and the creative tools of light, composition, color, and perspective based on what you want to say. Many years ago in a workshop, my good friend Dewitt Jones spoke about the importance of making a checklist for each photograph you take. I still use one, although it's now a subconscious list. Each question relates to concepts or equipment:

- Is the light appropriate for the subject?
- What do I want to be dominant?
- What do I want in the frame?
- Where do I need to be for great depth and angle of view?
- How much depth of field do I want or need?
- Do I need a slow or fast shutter speed?
- Would a tripod help?
- What's the range of light?
- Would a filter help?
- Is there a creative technique that would better express my vision?

With each answer, you build your creative image. Although many of these questions relate to technical issues, answer each one from the perspective of what you want to express with your photograph. If you wanted to show the vastness of the desert, you wouldn't choose a telephoto lens. Similarly, if you wanted to show the texture of a landscape, you wouldn't lie down on the ground to achieve your point of view.

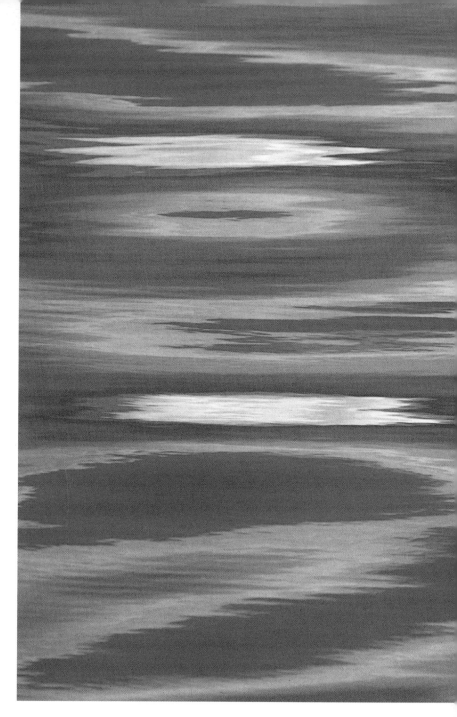

Using a list may sound like a guaranteed way to stifle creativity. Surprisingly, the opposite is true. After a short while, a written checklist becomes a mental list, then an intuitive list.

To achieve a level of skill at handling your camera equipment intuitively, you need to practice daily, like a musician. Carry your camera everywhere: Even if you can't make quality images, practice working with the camera and your lenses.

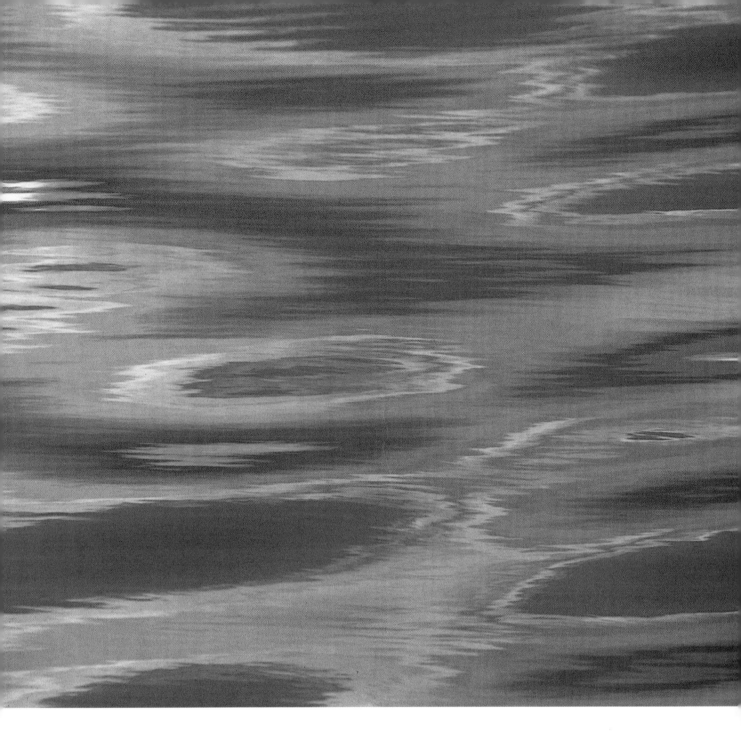

Learn which way a lens rotates to focus closer. Know how to compensate exposure on your camera quickly, how to switch auto-focus on and off, and how to change the focus points quickly. Master your camera's controls and know its features, so you'll no longer need to be fussing over what shutter speed or lens to use when the world is showing you its magic. The camera should be a conduit for creativity, not a technical block.

To develop visual skills, you need to look at things around you constantly. It would be wonderful to be able to stop and take time to photograph whenever you see something interesting, but I know that's not always possible. Make it a daily practice to see and compose. Not only will you improve and stimulate your photographer's eye, but you'll also improve the quality of your day as you see beautiful and interesting things.

WATER PATTERNS, ALASKA. Canon EOS-1n, 80–200mm lens, Fujichrome Velvia.

LIGHT

THE ESSENTIAL ELEMENT

Light animates. It's a soothing, therapeutic, exciting, thrilling, mutable force, and it plays itself out very directly on me, on my emotions.

—SAM ABELL

Light is the essential raw material of all photographs. Light defines a subject, expresses a mood, and sometimes enhances a moment. By its very definition, photography is "writing with light." To do this writing, outdoor and nature photographers rely heavily on available light. What this really means is that you head out into the field hoping that great light is available! Light is different every day; in some places, it's different every moment as clouds move overhead. This changeability is the magic of light.

If people aren't responding to your photographs, perhaps it's time to take a good look at the light in them. An image that lacks good light simply lacks visual impact, and usually doesn't garner any "oohs" and "aahs" from your viewer—unless they, too, don't know the difference.

Photographers have long considered early morning and late afternoon to be the best times to photograph outdoors. Light at other times, the consensus has it, is "bad light," so there's no need to take out the camera. Yet Ernst Haas, a master color photographer, once said, "There is no such thing as bad light. There is just light." If you reconsider how you define light, you'll find his

OLD FAITHFUL GEYSER BASIN, YELLOWSTONE NATIONAL PARK, WYOMING. Canon EOS-1n, 80–200mm lens, Fujichrome Velvia. *As the morning sun broke through the clouds of steam, it highlighted these hoar-frosted trees, leaving the background in soft light. The light was so great that I didn't realize it was −26° until I returned to the lodge two hours later.*

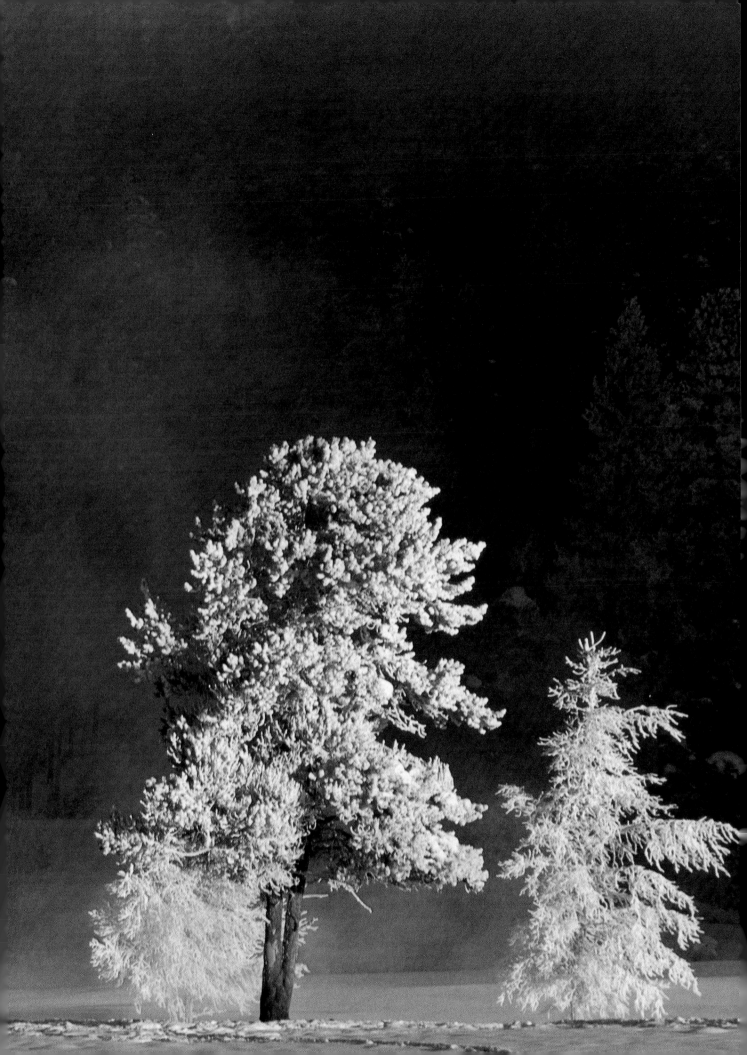

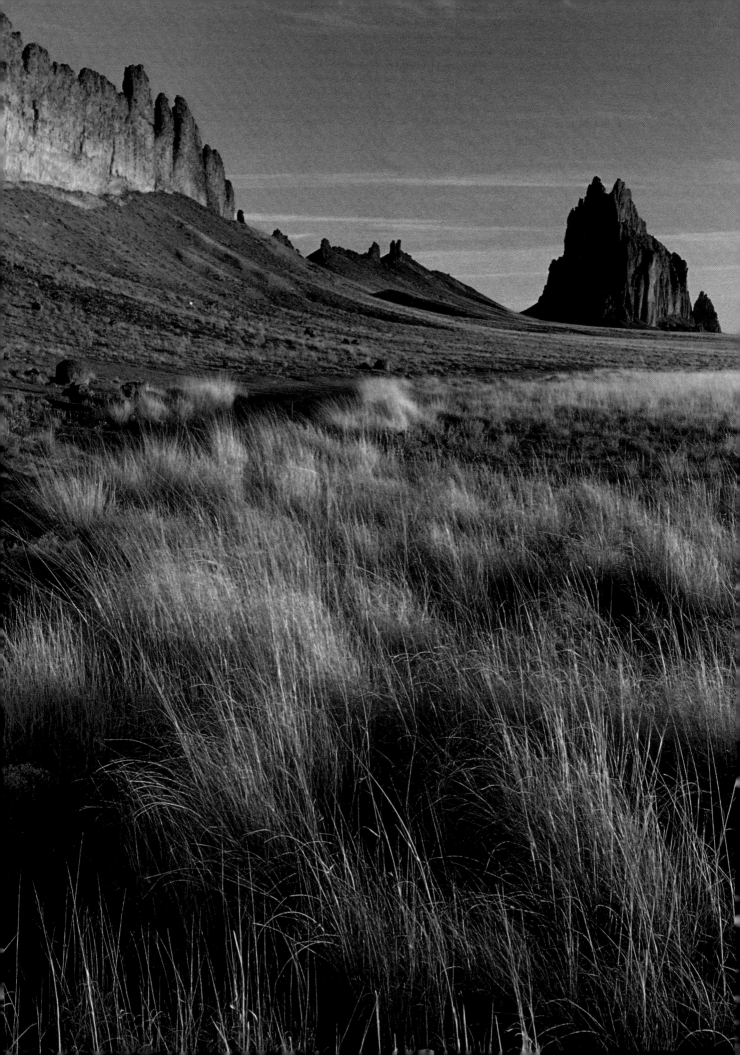

statement is true. Rather than define light as "bad" or "good," think instead of "appropriate light." With creativity and resourcefulness, you can make great photographs any time of the day using the idea of "appropriate light." Although I prefer the warm light and longer shadows that occur in the morning or afternoon for my landscapes, I also search for photographic opportunities during midday. Whether you're photographing a landscape, a flower, or a castle, you can find an appropriate light that will bring out the best attributes of your subject. So, actually, the best time to photograph is whenever the light is right for your subject.

For example, sunlight doesn't shine into many streets in European villages until midmorning, so I use the even light of open sky in the mornings to photograph detail images of doorways and gardens. Midday is the best time to photograph in the slot canyons of Arizona, where the overhead light streams in and bounces off the walls. I can plan to be in the desert for sunrise, then head to the canyon when the sun is too glaring on the desert landscape.

If I only photographed during early morning or late afternoon hours on a magazine assignment, I might not get the job done in the amount of time given. Looking for situations where I can use the midday light to create interesting photographs helps me to capitalize on my time. Of course, photographing all day means I may not get to read a good book or take a siesta!

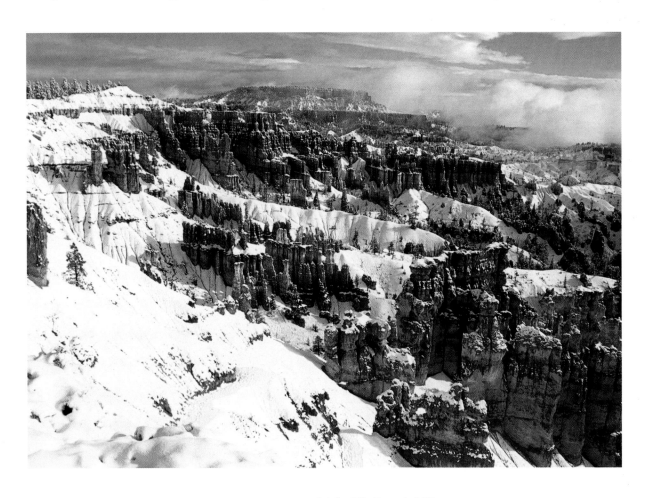

HOW FILM "SEES" LIGHT

Have you ever heard yourself saying, "Well, the light looked better than it does on the film" or, "It wasn't great light, but I made the image anyway"? It's easy to fall into the habit of thinking that the light will somehow magically be transformed as it is recorded on the film. Yet the difference between how we see light and how film "sees" light is substantial. Most slide films can only record a usable range of about three f-stops of light. Color print films have more latitude and can record a usable range of five f-stops. However, the human eye perceives about 11 to 14 f-stops between the brightest highlight and the deepest shadow. As you scan a scene, the pupils of your eyes dilate to let light in when looking at a dark area; they contract to reduce light when looking at a bright area. The eyes perceive detail in both areas.

Unfortunately, film doesn't see light the same way. Depending upon the range of light and dark values in your scene (known as tonal contrast), you may lose detail in the shadows if you expose for the highlights, and you may lose detail in the highlights if you expose for the shadows. It's no wonder that you don't always get what you see. When you know how your favorite films handle contrast, you can choose the appropriate film for the lighting conditions you encounter.

You can learn to recognize what conditions might be extreme, or too

CARMEL MISSION, CARMEL, CALIFORNIA. Canon EOS A2, 80–200mm lens, Fujichrome Velvia. *The scene was lovely, with lush bougainvillea and lantana, but the extreme range of light and shadow prevented the film from recording what I saw (left). When the fog bank moved in half an hour later, the diffuse light allowed me to capture a second image (right) with the details and rich colors I wanted.*

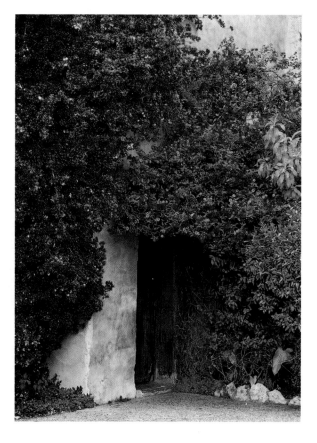

high in contrast, for the film. If you think a lighting condition is extreme, use the spot meter in the camera or a hand-held spot meter, and take readings around the scene to determine the range of contrast. If the contrast goes beyond three stops, you have to decide whether to expose for the highlights or the shadows. You'll generally want to expose for the highlights when using slide film and for the shadows when using print film. Even then, the difference of three stops may be too great to make a successful image. As you read on, this concept will become clearer.

THE CHARACTERISTICS OF
NATURAL LIGHT

Light has several significant characteristics: quality, direction, and color. I can't overstate the impact these characteristics have on your photographs. Photographers who don't understand the characteristics of light usually produce images that lack drama or emotion. Those who learn how to work with light will make infinitely better photographs. Not only will they illuminate their subjects well, they will also convey light's emotional symbolism.

Natural light can be specular or diffuse. Both come from a specular source, the sun. When nothing stands between the sun and the subject, the light is direct and produces sharply defined edges on objects. Specular light creates bright highlights and deep shadows, known as tonal contrast. Since film cannot record an extreme range of contrast, photographing in strong specular light can present a challenge. Light that is refracting off an object in full sun reduces the color saturation, and bright highlights and deep shadows create a contrast that is considered "busy" and hard on the eyes. It's

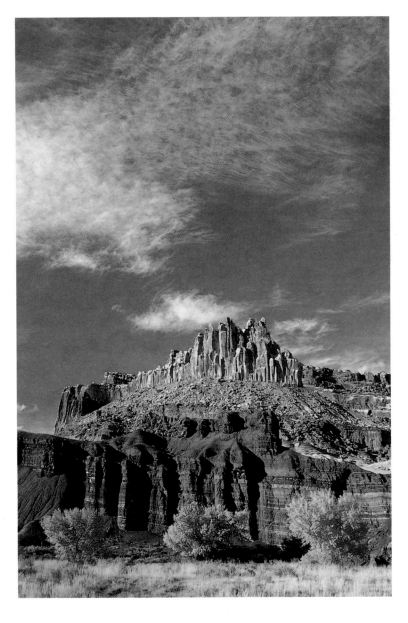

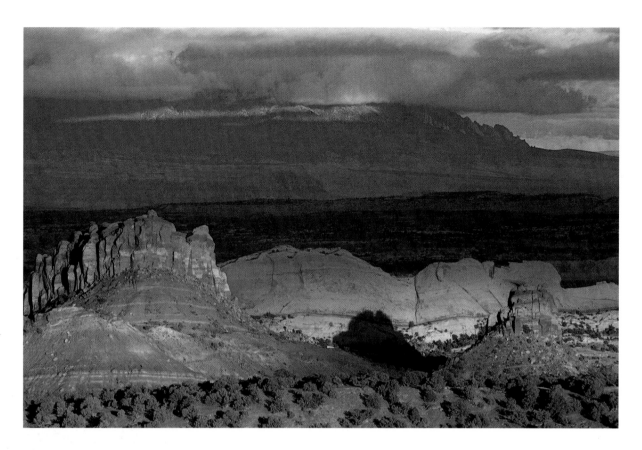

very difficult to photograph straight-forward close-ups of flowers or faces in strong sunlight. On the other hand, strong sunlight is great for defining the desert's wind-sculpted sand dunes, and sunlight breaking through storm clouds can produce wonderfully dramatic light.

From an emotional perspective, specular light is bold and aggressive. Direct sunlight represents energy, vitality, and heat, so it doesn't make sense to shoot certain subjects in strong sunlight. For example, you wouldn't be able to capture the delicate color and design of a blossom

Above: CLEARING STORM, CAPITOL REEF NATIONAL PARK, UTAH. Canon EOS-1n, 300mm lens, Fujichrome Velvia. *Along the Burr Trail, autumn storms bring great opportunities to capture the drama of the light. A break in the clouds brought direct sunlight onto the buttes and created long shadows behind them.*

Left: BISTI BADLANDS WILDERNESS AREA, NEW MEXICO. Canon EOS-1n, 28–135mm IS lens, Fujichrome Velvia. *The Bisti Badlands seem like they are on another planet. Strong afternoon sunlight created the bold shadow of the hoodoo and defined the hardened ash formations against the rocky ground.*

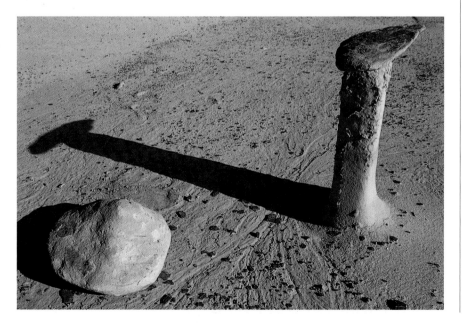

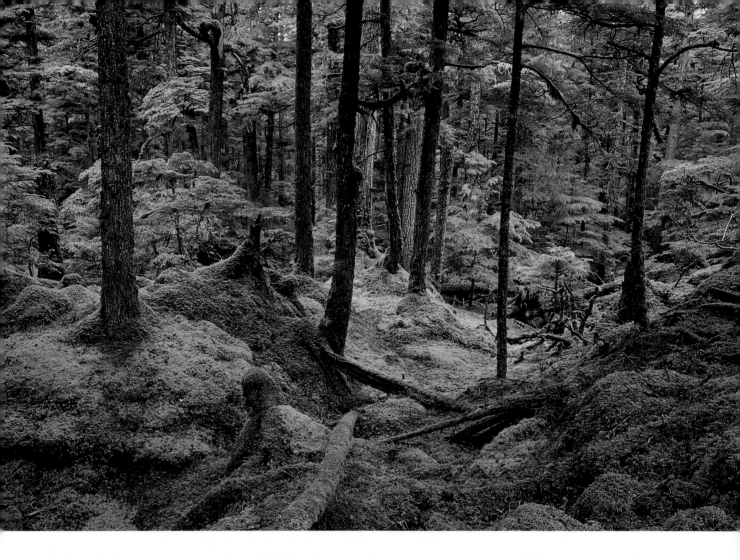

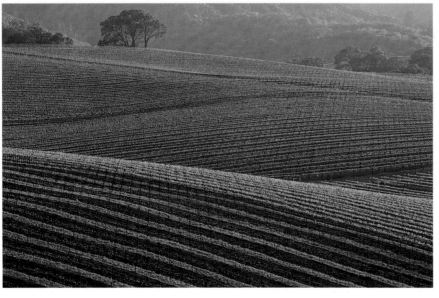

Above: TONGASS NATIONAL FOREST, SOUTHEAST ALASKA. Canon A2, 28–70mm lens, Fujichrome Velvia. *The diffuse, "quiet" light of a cloudy day provided what I needed to record the details of this mossy forest.*

Left: SONOMA COUNTY, CALIFORNIA. Canon EOS-1n, 80–200mm lens, Fujichrome Velvia. *Atmospheric haze softened the afternoon light spilling over this landscape, reducing the harshness of the sunlight and giving this vineyard an almost nostalgic feeling.*

in strong sunlight. Yet strong sunlight will allow you to capture a gorgeous day in a mountain meadow on film.

Diffuse light is sunlight that has been run through a filter of smoke, fog, marine haze, cloud layers, or materials like silk or nylon. Light beams from the sun hit this diffusion layer and scatter. Light coming from several directions at once, rather than a single direction,

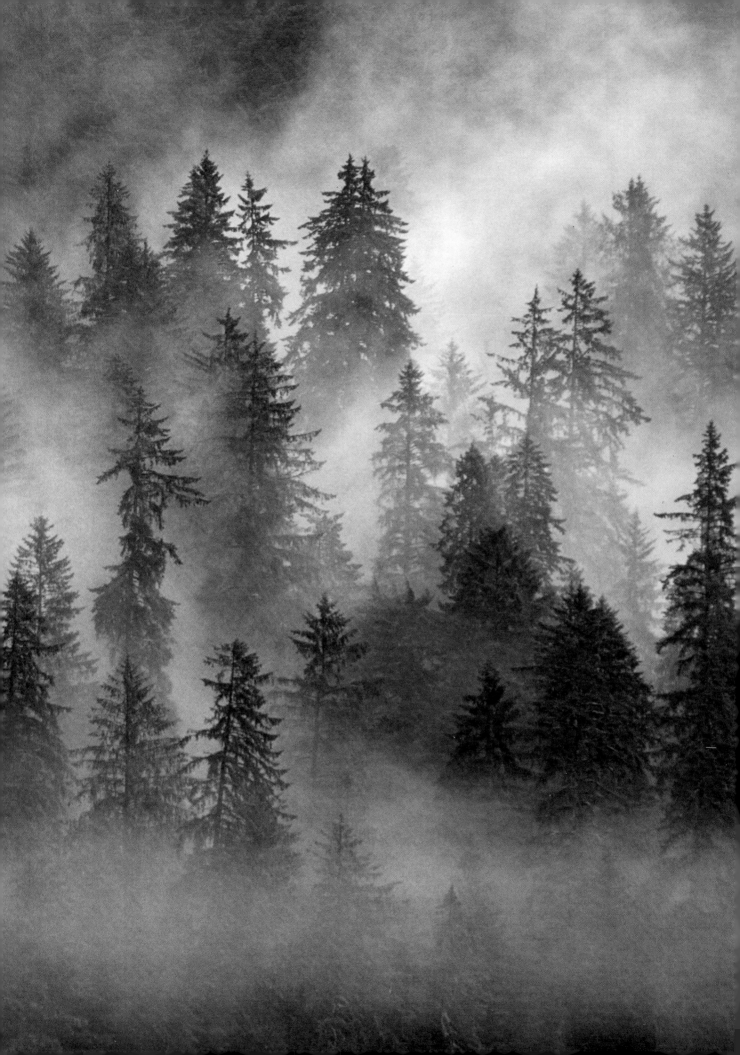

lowers tonal contrast. With the range of brightness compressed, the transition from highlight to shadow is much more gradual. As a result, colors appear richer, and you can record areas of highlight and shadow on film more successfully. Commonly called "quiet light," indirect diffuse light will enhance the delicate details of a flower, but it may make a meadow landscape dull and uninteresting.

In my workshops I am surprised to notice how many students will start to pack up their cameras at the first signs of rain or darkened skies. Every outdoor photographer exalts over the cheerfulness of a sunny day, but when the weather turns bad, serious outdoor photographers don rain gear and pack more film. Intimate details and moody landscapes await those who venture out into the diffuse light that comes

with fog, mist and rain with an open mind and an adventurous spirit.

Diffuse light is emotionally nonassertive. It quiets the spirit and suggests a coolness and peacefulness. Yet it can also suggest danger, as it does in the ominous skies that precede a storm.

Although diffuse light is generally better for macro and intimate views and specular light is usually more effective for landscapes, this is not a hard-and-fast rule. Every photographic situation is unique. What matters is that the light is right for what you want to photograph. As an exercise, photograph the same scene or object on a sunny day, a rainy day, even a partly cloudy day, and compare the results. Study them, and you'll learn how different qualities of light affect your subject and which type of light is the most evocative for that subject.

Above: BISHOP CREEK, CALIFORNIA. Both: Canon A2, 80–200mm lens, Fujichrome Velvia. *Just before the sun dropped behind the ridge, the strong light set the hillside ablaze with golden color. The light reflecting off thousands of tiny yellow leaves bounced into the shadow areas, lessening their density. After the sunlight was gone (right), the open sky illuminated the scene evenly, creating subtle hues and even more detail in the shadows. Both pictures work but express a different mood.*

Facing page: FOG IN FIR TREES, SOUTHEAST ALASKA. Canon EOS-1n, 80–200mm lens, Fujichrome Provia. *When the day dawns foggy and rainy, there are still beautiful photographs to be made. While others were content to read in the boat's warm salon, I went to the bow to photograph this atmospheric scene.*

THE DIRECTION OF LIGHT

The direction of light is constantly changing throughout the day as the sun shifts position in the sky. In the middle of the day, when the sun overhead, you essentially have toplight. Have you ever noticed how a midday scenic or portrait in full sun is usually not very exciting? Toplight from the sun often has extreme contrast, puts shadows in the wrong places, and is the least flattering of all the possible light directions.

Frontlight can be similarly boring. Many years ago, the rule was to photograph with the sun over your shoulder. And look at those photographs! Many people still make photographs this way, with uninteresting results. When light comes from over your shoulder, straight on to your subject, the shadows that give dimension to an object and depth to a scene are eliminated. Without dimension, the photograph is flat, and so is your viewer's response.

Frontlight is in effect even when the sun is at your back and low in the sky. When you face east at sunset, the landscape may be

Below: DEATH VALLEY NATIONAL PARK, CALIFORNIA. Pentax 6x7, 55mm lens, partially polarized, Fujichrome Velvia. *Morning sidelight skimmed the mud flows at Zabriskie Point, illuminating the ridges and eroded valleys of this unique area. As a result, the image seems like a tremendous bas-relief.*

Facing page, top: OAXACA, MEXICO. Canon EOS-1n, 75–300mm lens, Kodak E100S. *The low angle of morning light played over the stucco surface of this building, bringing out its texture. When the little boy walked into the scene, the sidelight also created the long shadow of his body, adding more dimension to the scene.*

Facing page, bottom: POINT REYES NATIONAL SEASHORE, CALIFORNIA. Canon A2, 28–135mm IS lens, Fujichrome Velvia. *Very high winds were scouring Drake's Beach one day, creating tiny hoodoos that reminded me of Bryce Canyon. The strong afternoon sidelight brought out the sculpted results and allowed me to capture a detailed view of the wind's powerful effect.*

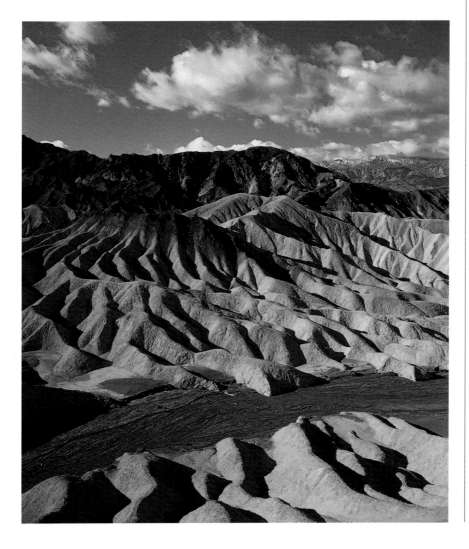

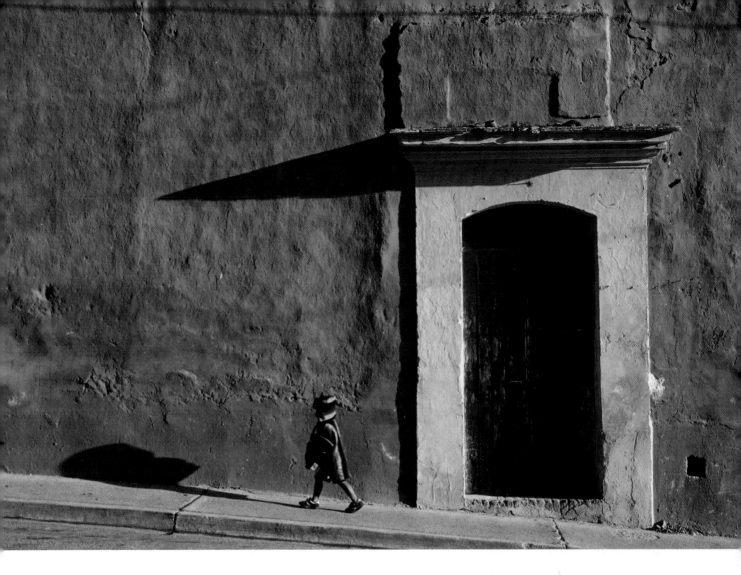

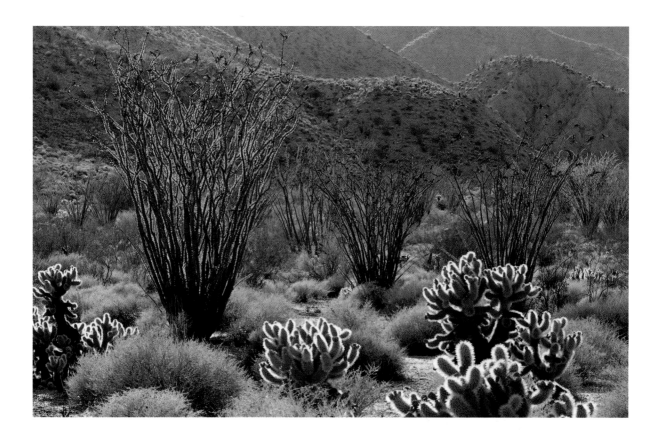

filled with rich golden hues. But just because the color of the light is wonderful, the direction of light is not necessarily the best. A mountain will still look better when illuminated by a little more sidelight than frontlight. A city illuminated by the last rays of sunlight, however, may look great. Don't be fooled by colorful light. For most nature and outdoor photography, sidelight and backlight usually provide the most pleasing results.

Professional outdoor photographers most often use *sidelight,* which gives a feeling of dimension to a landscape and defines the form of objects. Painters "saw the light" centuries ago when they used sidelight to give their work dimension. Photographers can use sidelight the same way. The low angle of sun in the early morning or late afternoon produces great sidelight for landscapes, bringing out the form of

objects and any texture that might be present.

Although obvious in the morning or afternoon, sidelight occurs any time your subject is struck by light at an angle. A vertical canyon wall can be sidelit at high noon. Even though the light is coming from overhead, it is skimming down the surface of the wall, producing the effect of sidelight.

Backlight is one of the most dramatic light directions. In close-up details, as the sun pours through translucent objects such as petals, leaves, or seedpods, backlight creates a glowing translucence. In landscapes, backlight can accentuate such atmospheric conditions as fog, rain, haze, mist, and smoke. Backlight defines the shape or outline of an object with rimlight. This is especially effective when you expose so there is little detail on the shaded side.

ANZA BORREGO DESERT STATE PARK, CALIFORNIA. Canon EOS-1n, 28–70mm lens, Kodak E100S with –⅔ compensation. *Morning sun poured softly over the hill and backlighted this desert "garden," rimming the cholla cactus with a golden glow and shining through the tiny green leaves of the ocotillo. To capture detail in the shadowed side of the plants without overexposing the backlighting, I took a spot reading off the shadow side of the cactus and compensated by underexposing.*

While it is exciting to work with backlighting, you must pay special attention to exposure. Since you can't take a reading off the rim-lit edges of your subject, you must read the shaded side. I usually spot meter and adjust my exposure based on the tonal value of the object. With a light object, I would spot meter off the shaded side and add light. If the object is dark—say a bison—I would subtract light. As a general guide, I've found that underexposing the shaded side about two-thirds to one stop works well. This still provides some detail on the shaded side, but brings down the overexposed highlights so they are not more than two stops overexposed. If you don't have a spot meter, you can use a telephoto lens as one. Or you can use the general rule of thumb of stopping down one to two stops below the meter reading. Practicing on a variety of subjects is the best way to get a sense of how to photograph backlit subjects successfully.

You can backlight scenes in early morning or late afternoon to evoke a feeling of warmth and energy, even nostalgia. These are great times to photograph, but with the low angle of the sun, light starts pouring into your lens and, whenever it shines directly onto the front element of the lens, can cause lens flare that reduces the overall contrast. The result is a hazy effect on the film. If you have the lens stopped down, it can also show up as a hexagonal shape on the film. When aiming into the sun, filters will cause more potential for flare, because the light bounces off the front lens element and reflects back off the inside of the filter. This is why you'll often get two suns in your photograph. To reduce flare in these circumstances, remove the filter.

REDWOOD BRANCHES, MUIR WOODS NATIONAL MONUMENT, CALIFORNIA. Canon EOS A2, 75–300mm IS lens, Fujichrome Velvia with –½ compensation. *The mid-afternoon sun shining through the new growth tips of redwood branches created an eye-popping scene. I photographed it against a dark, shaded background, first taking a spot-meter reading on the branches and then compensating by underexposing from the reading.*

"BY DAWN'S EARLY LIGHT"

CAMDEN HARBOR, MAINE

The plan had been to go inland to capture morning mist on a nearby lake, but when I saw the cloud formations overhead, I knew there was potential for a great sunrise, so the harbor was the place to be instead. It was the best light of the week, and cloud layers ensured that rich colors filled the sky for a good 40 minutes after the sun crested the horizon. The light that morning transformed the frequently photographed harbor into a magical place.

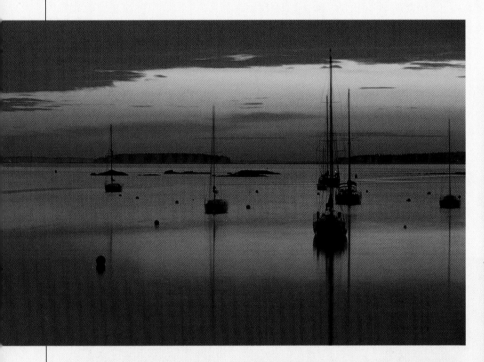

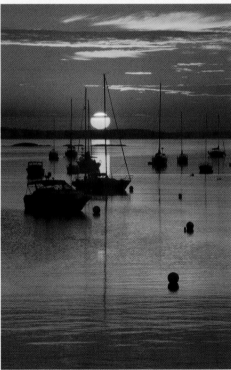

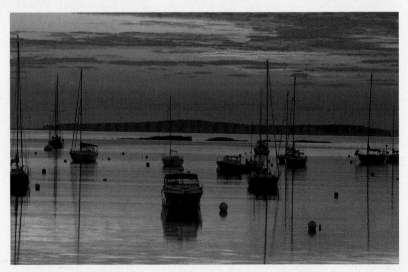

THE COLOR OF LIGHT

You don't need to be a scientist to photograph in color, but knowing a few basics about the color of natural light can help you make better outdoors photographs. You can learn to see the color of light and modify it to your advantage.

All natural light has a certain color that results from atmospheric conditions and the time of day. Scientifically referred to as color temperature, full midday light (white light) is 5500 degrees on the Kelvin scale, the standard for measuring the temperature of light. By comparison, the color of sunrise will measure somewhere between 2900 and 3400 degrees Kelvin. Yellow, orange, and red hues are considered warm; blues, purples, and greens are

considered cool. The color of light can enhance the mood of a photograph. Warm light feels nostalgic, safe, vitalizing; cool light feels tranquil or mysterious.

Warm light is easy to see in the hues of a good sunrise or a glowing campfire. Cool light is easy to see in the deep blue of twilight or glacial ice. It's the many variations in between these extremes that are most difficult for the human eye to discern, because the brain corrects for color shifts. Film, however, does not correct for color shifts. You must detect the color of light and its effect on your film. You could purchase a color temperature meter, but it's one more item to stuff into your bag. With just a little practice,

PARKER MOUNTAIN, EASTERN SIERRA, CALIFORNIA. Canon EOS-1n, 28–70mm, Fujichrome Velvia. *This clear autumn morning, a rising sun bathed the mountain peaks with warm, peach-colored hues. The warmth from the light meant I didn't need filters to create this pleasing palette of colors.*

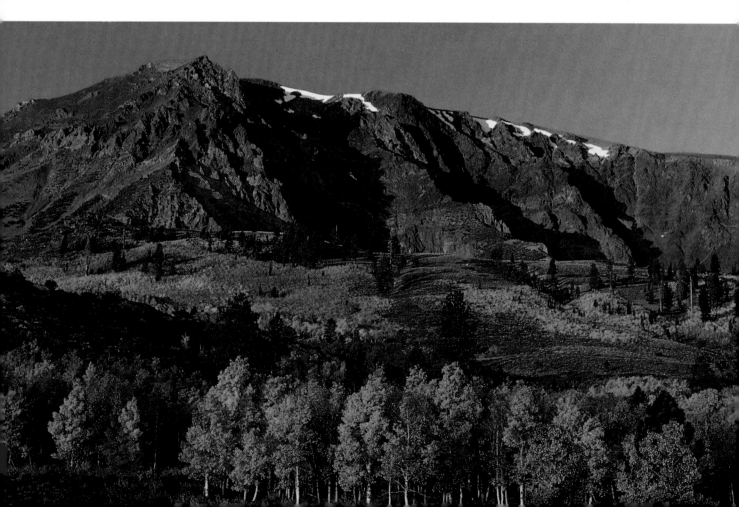

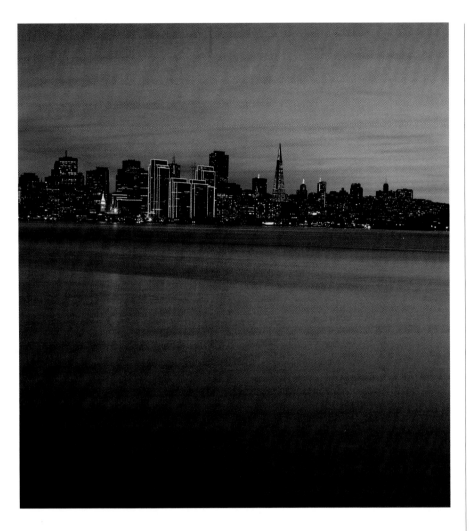

you can train your eye to see subtle variations of color temperature. The key is to remember what conditions or times of day produce a particular color of light.

The color of light affects the colors of objects in your photograph. For example, the orange light of sunrise will make a field of blue flowers look muddy brown. The cool blue light of an overcast day will drain oranges or reds of their rich hues. Generally, blue light from open shade neutralizes any warmth in the colors of your scene. If you want to convey the coldness of a winter day, however, this color of light can be perfect.

Don't forget that altitude affects color temperature, because in high elevations there is less atmosphere to scatter and therefore warm up the light. Even under sunny conditions, you may have cooler light than you expect. It's easy for the eye to be tricked.

MODIFYING THE LIGHT WITH FILTERS

You can alter the color of the light by using filters, and, as an artist, you make the choice of how subtle or obvious you want the color to be. If you want to control the color of light and maximize your opportunities in the field, you must keep a few basic filters in your camera bag. In certain situations, I can't do without them. I mostly use filters when I feel they will enhance my images, by either color correcting for blue light or enhancing the natural light a little. On occasion, I will use special-effect filters.

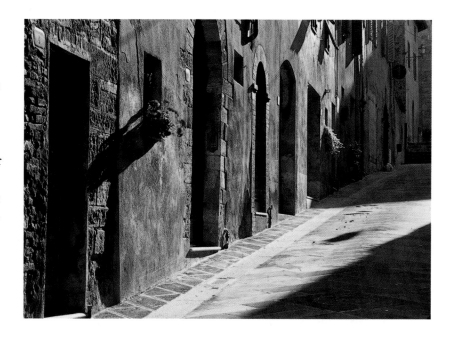

WARMING FILTERS

A warming filter is an essential in any outdoor photographer's bag. Even better is a series of warming filters, because the variable color of light will require different levels of filtration. Warming filters counterbalance blue light by blocking the blue wavelengths coming through the filter, allowing the other colors to come through. These filters range from 81A to 81EF; starting with A, each has a progressively stronger warming factor. One of these can usually neutralize blue light. For more creative results, you can go beyond just neutralizing the light and warm up the scene even more by varying the strength of the warming filter. I keep an 81B filter on my lens most of the time, especially when I know I'll have to move quickly from shade to sunlit areas. The 81B helps to block some of the blue light of the shade, and it adds a little more warmth to the sunlight in the others areas. It's great for warming up skin tones, too.

My other favorite is an 81C. This filter has been very useful in high altitudes, where the blue spectrum is stronger than it is at sea level. If I really want to warm up a scene, I use an 81EF. On a recent assignment in Tuscany, this filter did a great job with the stone houses. An 85C also enhances the warmth of daylight and provides natural-looking but extra warm color. I often use it in the morning or afternoon to extend the duration of "magic light" by about an hour.

POLARIZING FILTERS

These wonder filters eliminate the glare on water and wet surfaces, reduce reflections on glass and other shiny surfaces, and reduce the effect of atmospheric haze to produce deep-blue skies. Polarizing filters

Above: VILLAGE LANE AND GERANIUMS, ITALY. Canon EOS-1n, 28–135mm IS lens, 81EF filter, Fujichrome Provia 100F. *The stone walls and alleys of this hilltop town in Tuscany remain in deep shade until mid-morning, and by then the light is a neutral white. To bring back some of the warm hues of the stone, I used an 81EF filter.*

Facing page: UNNAMED CASCADE, OLYMPIC NATIONAL PARK, WASHINGTON. Canon EOS-1n, 80–200mm lens, Fujichrome Velvia. *In the top photo, to keep the scene's feeling of coolness I used only an 81B filter, which warmed up the scene only slightly. In the bottom photo, I used an 81C, which removed most of the blue light. Does it still have the feeling of cool freshness? Decide for yourself if you prefer this image or the one above it.*

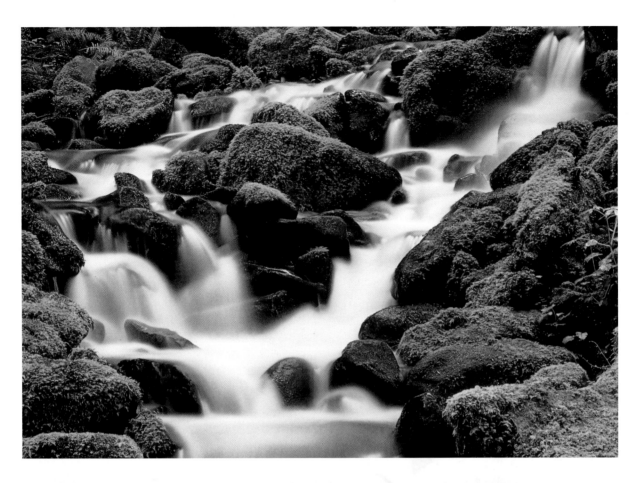

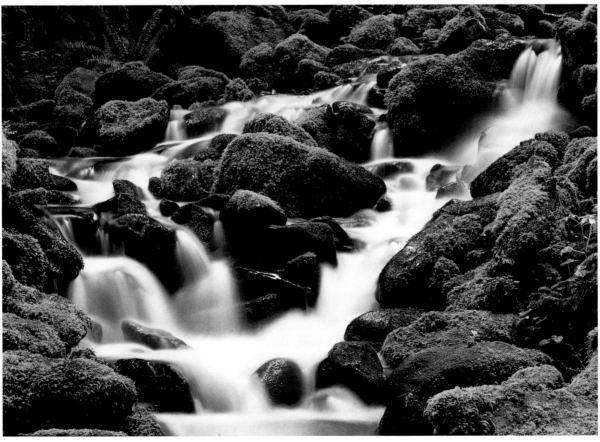

work best when used at a 90 degree angle to the sun by eliminating extraneous, scattered light, but they can also be effective at lesser angles.

Polarizing filters are great in the forest and on cascades of water. They enhance the color saturation of the foliage by minimizing reflections from waxy leaves, and they remove some of the glare that comes off wet rocks. By eliminating the surface glare, you can also see into tidepools and shallow ponds. I use my polarizer more under these circumstances than I do on a sunny day. Despite these benefits, I use my polarizers sparingly and carefully. While a scene may look great in the view-finder, the results are often too saturated on the film. An over-polarized sky can become an unnaturally deep hue, and some colors literally pulse when polarized. I usually don't want either of these effects for my nature and outdoor photographs.

GRADUATED NEUTRAL DENSITY FILTERS

How outdoor photographers managed for so long without these wonderful filters is beyond my comprehension. Graduated neutral density filters (commonly called graduated ND filters) allow a photographer to balance, or compress, the range of light in a situation that is normally too extreme for the film to record, especially with transparency film. Graduated ND filters are clear on one end and gradually shaded to a neutral gray at the other. They come in densities that are equivalent to the range of f-stops, from clear to neutral gray, as one-stop (.3 ND), two-stop (.6 ND), and three-stop

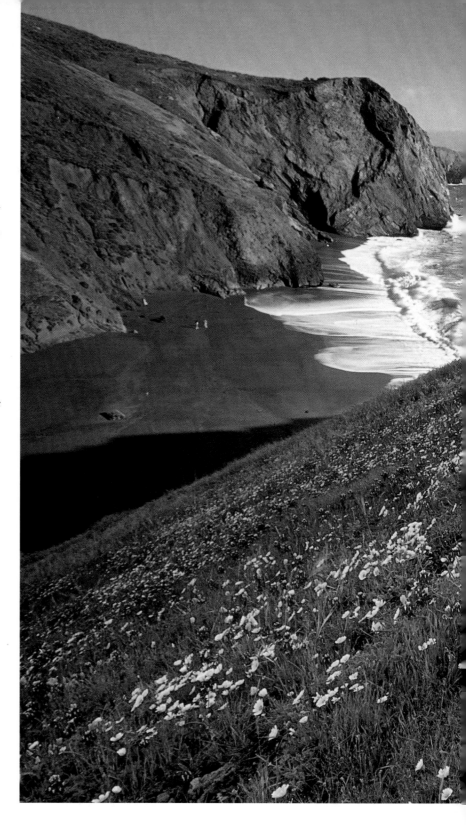

(.9 ND). You can choose between a soft-edge or hard-edge, which describes the division between the neutral density and clear sides of the filter. If you are just learning to use graduated ND filters, a two-stop (.6 ND) soft-edge is a good choice because of its versatility.

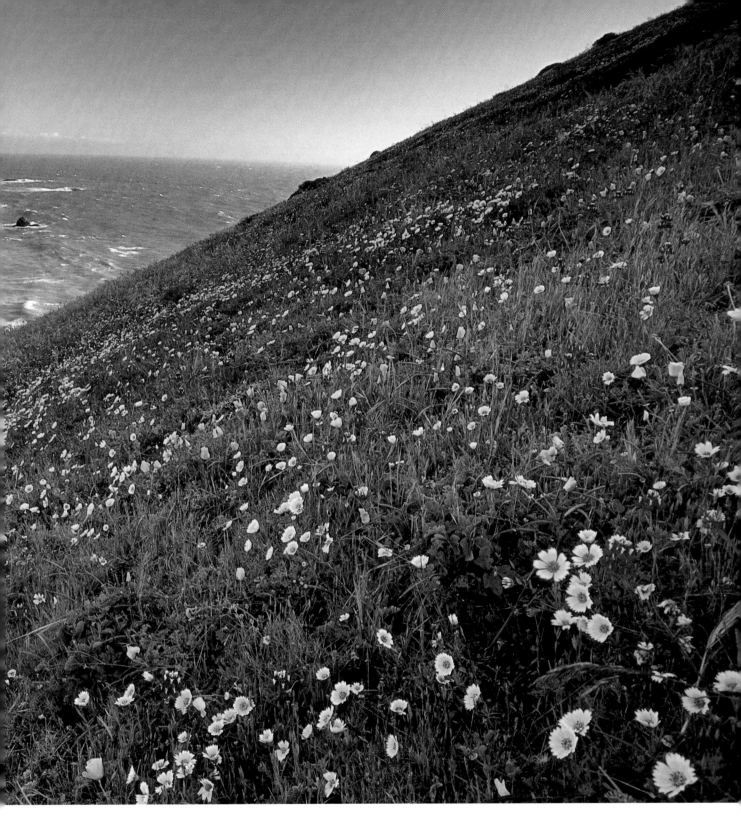

You'll most often use these filters when photographing landscapes in which you cannot correctly expose both the sky and the foreground without the filter. It's not uncommon in the beginning to have difficulty recognizing the need for a graduated filter.

Remember that your eyes see details in both areas without any problem. Train yourself to remember that film "sees" light differently and to recognize common situations where the range of light, or contrast, may require a graduated ND filter.

MARIN HEADLANDS, CALIFORNIA. Canon EOS-1n, 24mm tilt-shift lens, 3-stop grad, 81B filter, Fujichrome Velvia. *After metering, I reasoned I needed a 2½-stop filter, so I chose the 3-stop (.9 ND), which brought up the light level of the foreground meadow.*

You typically need a graduated ND filter when you are aiming toward the light while photographing sunrise and sunset landscapes, and for landscapes with reflected water. Yet there are other ways to use a graduated ND filter beyond reducing the light of the sky. Imagine a canyon where one wall is in sunlight, the other in shade. Expose for the sunlit wall, and the shaded side of the canyon will be dark. Expose for the details in the shade, and the sunlit side will be grossly overexposed. If you adjust a graduated ND filter to match up with the line separating the dark and light areas, you can record the detail on both sides.

What if you have a snowy meadow against a deep blue sky? The snow is brighter than the sky, so if you expose for the sky, you will lose detail in the snow. By using the filter upside down, you can block light reflecting off the snow and bring the range of light into a better balance.

The more you practice using these filters, the more you'll know when they are necessary, and the more you'll find creative ways to use them to solve your lighting problems.

Once you have mastered using a graduated ND filter, you might want to try using color graduation filters. For example, when the sunset isn't as saturated as you had wanted, a sunset graduation filter can help bring out a little more vivid color. You can also enhance the blue of the sky with a graduated blue filter. The variety of color and special effect graduated filters is overwhelming, but an outdoor photographer who wants photographs to retain a natural appearance can choose just a few.

OTHER FILTERS AND DEVICES

Aside from warming and graduated filters, I carry an FL-W filter wherever I go. Designed to block the green spectrum of fluorescent lights,

Facing page, top: PLEASANT CREEK, CAPITOL REEF NATIONAL PARK, UTAH. Canon EOS-1n, 28–135mm lens IS lens, Fujichrome Velvia. *Blue/gold polarizing filters can be very helpful when you want a little more color in your scene. In the image on the right, I turned the polarizer to enhance the gold hues and created a nicer light where the canyon wall reflected in the water. And the photograph still retained some of the blue from open shade in the frothing rapids. I also slowed down the shutter speed to soften the movement of the water when I filtered for the image on the right.*

Facing page, bottom: ABBAZIA DI SAN GALGANO, ITALY. Canon EOS-1n, 28–135mm lens, Warm Pro-Mist filter, Kodak E200. *This ruined stone abbey had a wonderfully ethereal, ancient feeling that I enhanced with a warm/diffusion combination filter. In exposing correctly for the interior, the window light was overexposed, which enhances the effect of the diffusion.*

BALANCING ACT: A QUICK METHOD FOR USING ND FILTERS

Imagine a beautiful meadow with granite boulders in the foreground and a mountain in the background. Morning sun shines on the mountain, but the meadow is still in shade. If the meter reading off the mountain is more than two stops different from the meter reading off the meadow, you'll need a graduated ND filter to expose both areas properly on slide film.

The easiest and fastest way to use a graduated ND filter is to match the gradation line on the filter with the line between the light and dark areas of your scene. To see the line on the filter, use the depth-of-field button on the camera to stop the lens down.

Once you have the line placed where you want it, meter your scene using matrix or evaluative metering. The darker (density) portion of the filter will compress the range of light, enabling most cameras to accurately meter the scene. However, this technique does not always ensure that the exposure for the shadows and/or the highlights will be correct.

With all but hard-edged filters, it's not always easy to see the line, even when the lens is stopped down. Try folding a piece of paper and placing it over the top edge of the filter, to the point where it meets the line on the filter. This makes the line obvious so you can adjust the placement accurately.

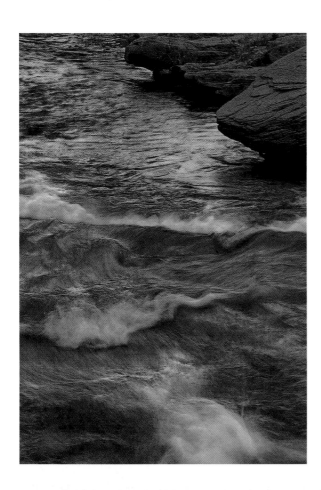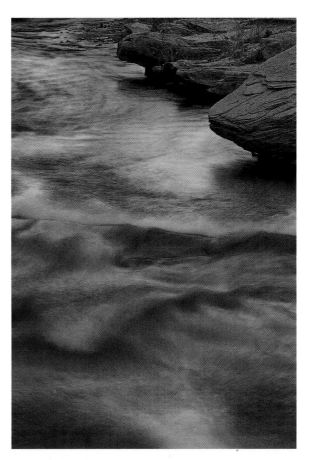

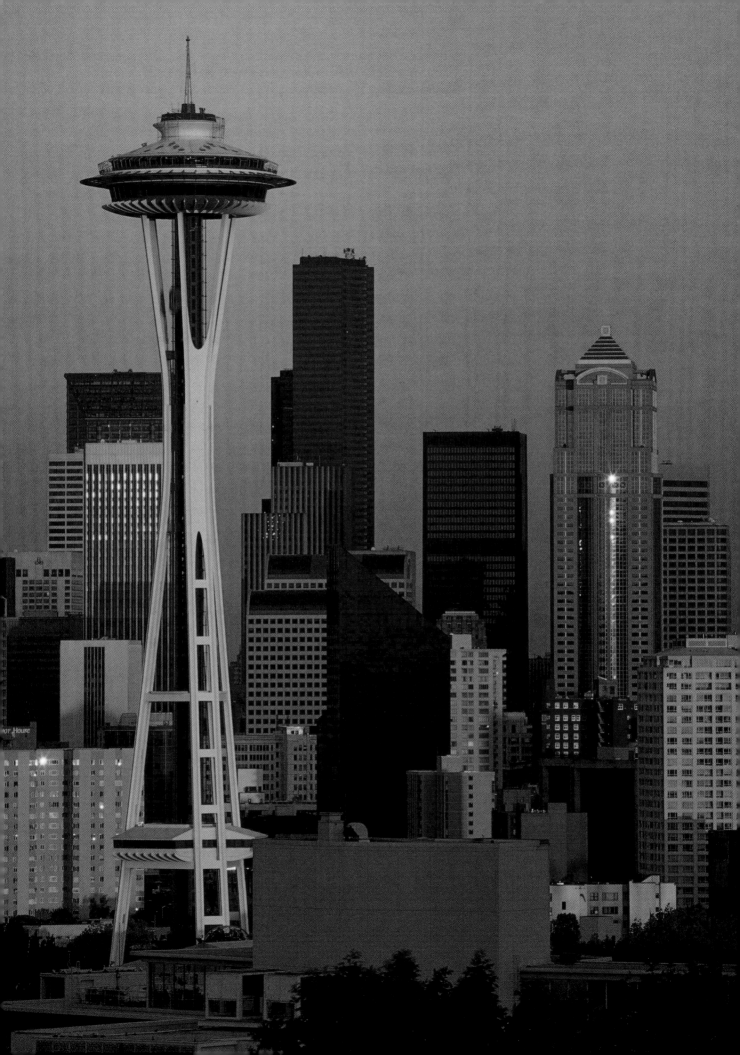

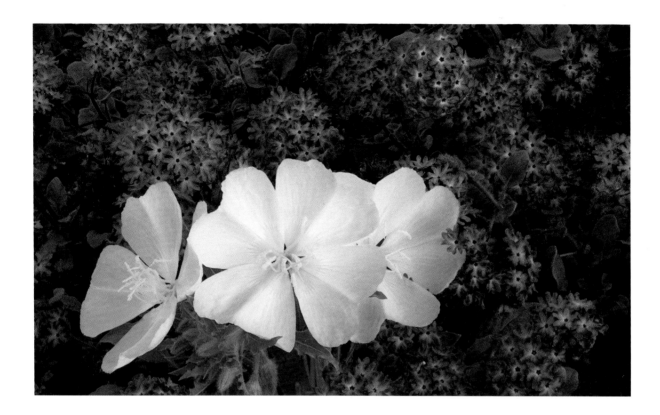

this filter is terrific for photographing skyhlines at twilight, and for enhancing a sunset that doesn't quite glow like you had expected it to. This filter can make your photograph garish if you don't use it carefully, but it's a filter worth having in the camera bag.

I really use other filters only for special effects. These include a warming/diffusion combination, a sepia/fog combination, and a gold-blue polarizing filter. When I want to create an ethereal effect, the warm pro-mist does a great job. I'll often use it with higher speed films, so the grain and the filter create the effect I'm after. The gold-blue polarizer can turn an ordinary reflection into an extraordinary one, but I use it sparingly so the reflection looks natural. (See the resources list on page 158.)

Outdoor photographers don't have total control over the light, but you can use tools to make the most of the light you have. If you want to do close-up photography and can't

wait for the light to soften, you can make your own diffuse light by placing translucent fabric between the sun and the subject. Diffusers are available as ready-made discs that fold up with a twist of the wrist, making them compact and convenient to carry into the field. I never leave home without mine. They're great for diffusing the light in close-up work and for photographing people.

What if you have strong sunlight and you don't want to alter the quality of the light, yet you need to balance the contrast? You can use reflectors or fill-flash to compress the range of light so the film can better record detail in both the shadows and highlights. The key to successful "fill," however, is to make it appear as natural as possible.

The most commonly used reflectors are round, collapsible discs that are available in a variety of colors and surfaces. (See the resources list on page 158.)

Above: DUNE PRIMROSE AND SAND VERBENA, MOJAVE DESERT, CALIFORNIA. Canon EOS-1n, 90mm tilt-shift lens, Fujichrome Velvia. *The sun was already strong when I discovered these beautiful flowers. To create my own diffusion, I unfurled a silk fabric disc. The softer light allowed the film to record a full range of detail in the image, including the delicate pale yellow in the centers of the primrose.*

Facing page: SEATTLE, WASHINGTON. Canon EOS-1n, 80–200mm lens, FL-W filter, Fujichrome Velvia. *The light wasn't all that rich in color when I arrived to photograph Seattle's skyline one afternoon, so I decided to experiment with an FL-W filter to liven things up. This filter works really well just after sunset, enhancing any pink hues in the sky and reducing some of the green glow from the building windows.*

DEMYSTIFYING FILL-FLASH

Flash has always been a "problem" among photographers who live and die by available light. I've seen many overly lit pictures from good photographers who've attempted to use fill-flash. Especially in nature and with available light, you should be working to balance the existing light, not trying to overpower it with the light from the flash. If people who look at the picture say, "Oh, I see you used fill-flash," you've used too much. It's all about proportion. If you learn how to set your flash correctly for natural-looking fill light, you can create very pleasing results.

The first challenge is to learn when you need fill-flash. On a sunny day, the extreme range of light will prevent you from getting both highlights and shadows on the film. If you are using slide film, you'll have to expose for the highlights. The shadows may become black holes, void of much detail on the film.

Yet how much flash do you use to fill in the shadows? First, it's important to keep the effect of the flash invisible in most outdoor situations. Let's use a basic scene of a sidelit rock that is half in dark shadow. Meter off the sunlit side, then the shadow side, and determine the difference. Let's assume it's three stops apart. By setting the camera meter for the sunlit side and setting the flash to put out less light than the camera reading, you will fill in the shadow details. Generally, in bright sunlit situations I set my flash in the range of −1⅓ to −2 stops; this keeps the flash from becoming too obvious.

You may also want to use fill-flash on an overcast day when the light is extremely flat and when forms are not defined or colors don't "pop." When I'm in the forest, under diffuse light, I still use my flash, set down around −2 or more, to throw just a "kiss" of light onto my subject and help the color stand out more. When I photograph people outdoors in full sun, I use a range of −⅔ to −1⅓. In general, sunlit situations require more fill-flash, and diffuse conditions require less. It used to take me weeks to figure this stuff out, but I ran a series of tests and now know the settings I need for certain conditions. You should also do these tests for yourself. Using the same subject, make an exposure using all the compensation settings for fill-flash, then decide which one gives the best results. Do this for sunlit and diffuse light conditions, and soon you'll feel more confident using fill-flash to improve your photographs.

One critical thing about flash is the quality of its light. Flash is a specular source, so it produces very harsh light, with strongly defined shadows. For best results, you'll want to soften the light for most nature subjects, and most likely for your photographs of people, too. I use a few products, but my favorite for natural-looking flash in outdoor photography is the Omni-Bounce Diffusion Box. (See the resources list on page 158.) Made of translucent plastic, this little box fits over the flash head and "wraps" the light around your subject by scattering

the light from the flash head in all directions. It fits easily in my camera bag, it's inexpensive, and when stored upside down in your bag it can hold a stash of AA batteries.

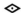

All of these are great tools to help modify or control the light once you have learned the characteristics of natural light and how to work with it. The more practice you get in the field, the more you'll develop your ability to see light and to pre-visualize the scene or subject under different lighting conditions. Learn how to recognize the best light for the situation, and you can use the magic of light to enhance your photographs.

EVALUATING YOUR EXPOSURE

All camera meters are calibrated to read 18 percent reflectance of light, the equivalent of middle-tone gray. No matter what the true tonality of your scene is, that is how the camera will render it. If you don't want medium-gray snow or medium-gray black bears, you'll need to adjust your settings before you trip the shutter. Although the meters in today's cameras are far more sophisticated than those made a few years ago, there are conditions under which the camera's meter reading will be incorrect.

The best way to obtain the correct exposure is to spot-meter your subject and decide whether it is lighter or darker than middle-tone or, more important, what you want it to be. You can also spot-meter areas that are middle-tone in your scene, provided the light on them is the same as it is on your subject.

If your camera does not have a built-in spot meter, you can use a middle-tone card to read the reflected light as long as it's the same light that's reflecting off your subject. This doesn't work if you are photographing sunsets or if you are in shade and your subject is in the sun or vice versa. This technique can work for many other situations, though, so use a middle-tone card as a reference until you develop your skills at evaluating light using the objects and areas in the scene.

As a general guide, less than 18 percent reflectance occurs off evergreen trees, dark fur, lava flows, and deep-colored wildflowers (such as larkspur), causing your meter to overexpose as it tries to make the dark subject middle-tone. You should compensate by underexposing. More than 18 percent reflectance occurs off light subjects, such as beige sandstone, snow, light desert mud, andyellow aspen leaves, causing your meter to underexpose as it tries to make the light areas middle-tone. Compensate by overexposing.

The following chart will help if you meter only the main subject using spot-metering:

SUBJECT BRIGHTNESS	COMPENSATION
Mid-tone	none
Snow on an overcast day	+2 stops
Bright snow on a sunny day	+1½ stops
White subjects with detail	+1½ stops
Very light subjects	+1 stop
Somewhat lighter than middle tone	+½ stop
Somewhat darker than middle tone	−½ stop
Very dark with detail	−1 stop
Black objects	−1½ stops

In general, don't overexpose highlights when using slide film, because the loss of detail yields bright areas that draw attention away from the main subject. However, you can overexpose a highlight by about ⅓ to ½ stop if the highlight is a small percentage of the image and doesn't draw the eye away from the main subject.

VISUAL
DESIGN

*It is the kind of photography in which the raw materials—
light, space, and shape—are arranged in a meaningful and
even universal way that gives grace to ordinary objects.*

—SAM ABELL

The success of a play depends in part upon a well-designed set that creates a pathway for the movement of the actors and establishes a tone, or mood. Photographs need a well-designed "set," too, where line, shape, form, pattern, texture, and perspective are the essential elements that come together to create an appealing image. Each element carries a symbolic value and has unique attributes. For example, lines can be aggressive or passive; patterns can be dizzying or organized. This symbolism comes from deep associations with objects.

Most photographers haven't really thought about the elements of design in their pictures. They consider the objects simply as objects, not as lines or shapes or patterns. You must have a deeper perception to see visual design elements in the world. After reading this chapter, I hope you'll look at the world around you differently. If you incorporate some of these design elements in your photographs, your pictures will have more visual impact, whether they are close-up details, scenics, or action images. Remember, each element contributes to building your "set," so every one of them is important.

LUNDY LAKE, EASTERN CALIFORNIA. Canon EOS A2, 80–200mm lens, Fujichrome Velvia. *The hillsides, reflected in the calm water before dawn, created a strong graphic study of shapes and color.*

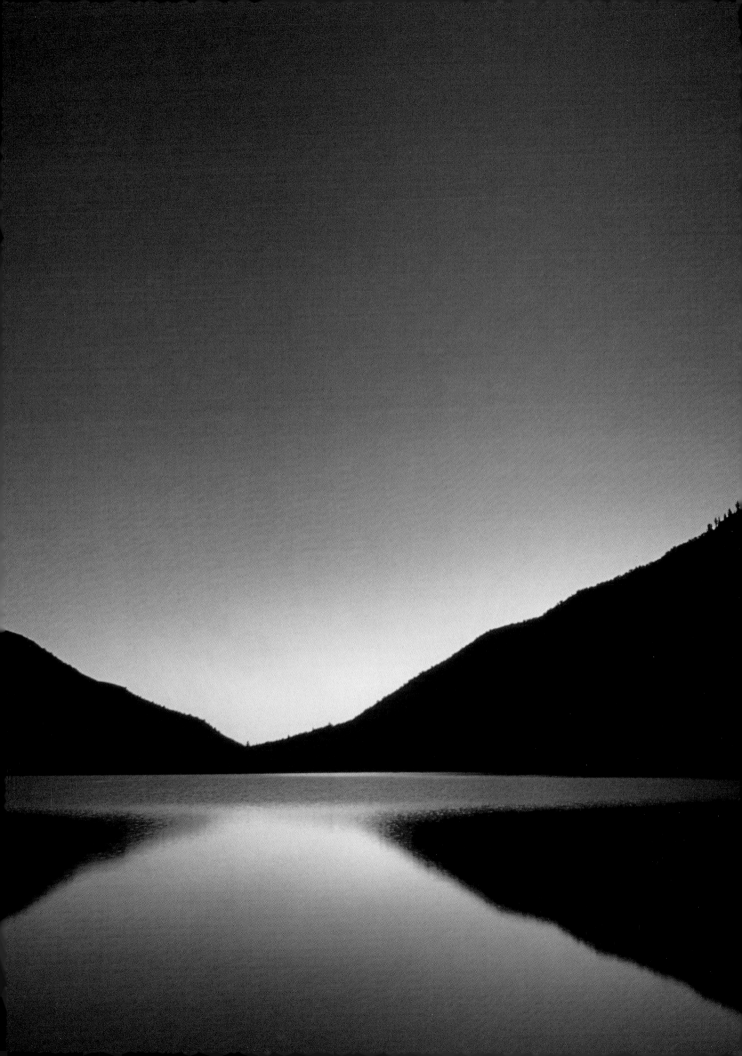

LINE

Lines are the most prevalent design element, defining shapes, clarifying spaces between areas, and visually leading us places. Lines bring structure to a photograph and possess visual strength. There are really only two types of lines: straight and curving. Straight lines have a sense of purpose, taking you directly to and from areas in the scene. Curving lines create a more relaxed trip through a photograph.

Like all design elements, lines contain powerful symbolism. Smooth, curving lines are sensual or tranquil. Jagged, zigzag lines suggest tension or represent danger. Straight lines convey rigidity and structure. Straight lines can be horizontal, vertical, or diagonal, and each direction evokes an emotional response. Lines also carry visual weight—a thin line has less impact than a thick line.

Lines powerfully direct the eye. Magazine and book designers often use this fact, consciously positioning images to visually move you toward the edge of the page and into the next one. Lines can be a great addition to a photograph, but they can also divide an image or take the viewer places you don't want them to go. It's important to recognize the significance of lines and to learn how to use them well in a photograph.

Facing page, top: SUNSET FROM STEPTOE BUTTE, EASTERN WASHINGTON. Canon EOS-1n, 80–200mm lens, Kodak E100S. *I was above the land, so the horizon flattened out, despite the area's hills. Including the sun and the grain elevator makes for less emphasis on the flat horizon.*

Below: PEACOCK. Canon EOS-1n, hand-held, 80–200mm lens, Kodak E100S. *Have you ever noticed the back side of a peacock in full display? The white lines of cartilage in the dark feathers create an eye-popping design of radiating lines. I thought the little "cotton" tufts on the tail were also interesting.*

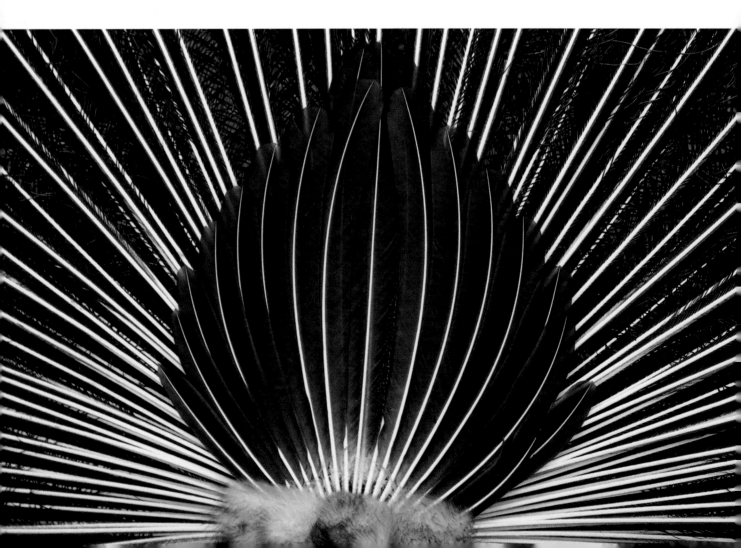

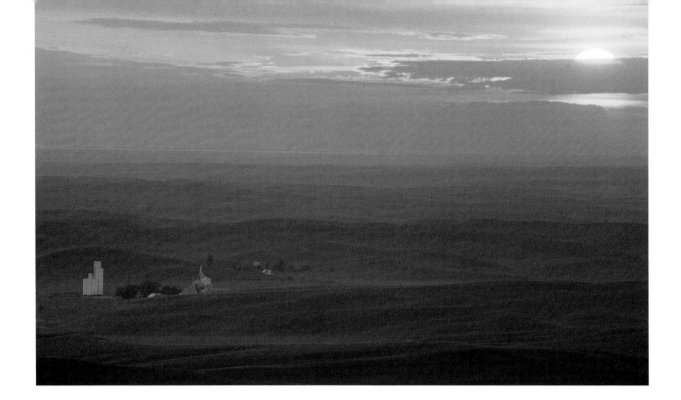

HORIZONTAL LINES

A straight, horizontal line, such as the line defining the horizon where the ocean or a wheat field meets the sky, imparts a calm, stable feeling and can convey the breadth of a place. Look at of some of your favorite landscapes, and see whether horizontal lines or horizontal bands are part of their appeal and how you can incorporate them into your compositions. The shoreline of a lake or pond can be a horizontal line, as can trees at the base of a mountain range, fences, or a row of long, low buildings. The rows of flowers in a commercial farm can represent horizontal bands of color; they can become a strong graphic element in your composition.

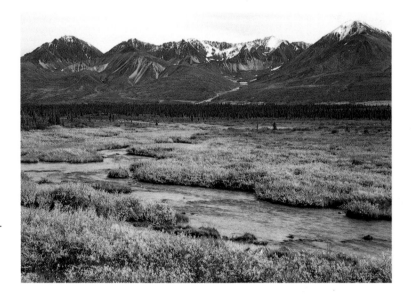

You can deliberately use horizontal lines to create photographs that express a calm, pastoral mood. Unless you want a symmetrical effect, try to keep any strong horizontal line out of the middle of your frame when composing. It will divide the photograph too equally, and the resulting lack of visual tension can make the photograph static or boring. If you can, try placing the horizontal line just above or below the section of the photograph you want to emphasize. If the horizon is unbroken, try framing your scene vertically to create a more dynamic image and reduce the eye's travel along the line.

Some photographers are known for their images of empty space in which only a simple horizon line divides the sky from land or sea. The calming power of some of these

Above: FISH CREEK, DENALI HIGHWAY, ALASKA. Canon EOS-1n, 28–135mm IS lens, Fujichrome Velvia. *I pushed the dark green line of fir trees, an obvious horizontal, into the background to keep it from bisecting the image and instead emphasized the yellow foliage of the willow bushes. The horizontal plain and the line of firs makes this image calming, even though it's ablaze with color.*

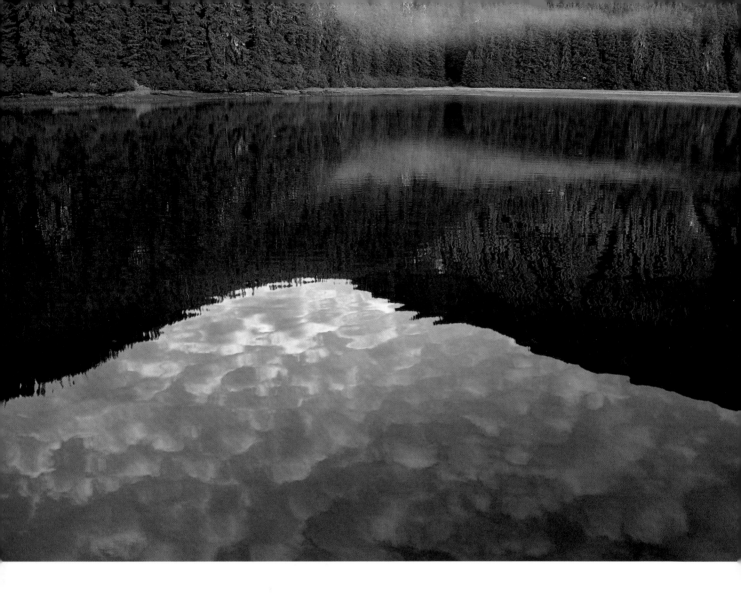

photographs is amazing—the image is simplified to such a degree that we are forced to look at just spaces of color or texture and to contemplate them for what they are. To make images like these, photographers give a great deal of thought to spatial and color relationships.

VERTICAL LINES

Vertical lines possess more energy than horizontal lines do. After all, a person usually seems more energetic when standing up than when lying down, and for that matter, so does a grizzly bear. Columns, towers, lighthouses, flagpoles, and towers lend powerful vertical lines to a composition. So do trees, cattails, flower stalks, and waterfalls, although they are less rigid and are not perfectly straight.

Vertical lines are assertive and direct, and they impart a sense of height to a composition that we interpret as power, order, and strength. An orderly line-up of people often suggests power. A towering redwood tree certainly imparts a sense of strength, as can a slender blade of grass—provided you compose your image to emphasize the blade's vertical orientation. Like a horizontal line, a vertical line will produce visual stasis if it divides a photograph too uniformly. For a more interesting photograph, try to compose an image so a vertical subject is off-center.

SCENERY COVE, SOUTHEAST ALASKA. Canon EOS-1n, 20–35mm lens, Fujichrome Provia. *"The early bird gets the worm" is a motto on my annual photo tour in southeastern Alaska. Lucky for me, it proved to be true one calm morning. I placed the horizon line high in the frame to emphasize the reflection, including just enough of the land above the water line to create a small section of symmetry with the cloud and its reflection.*

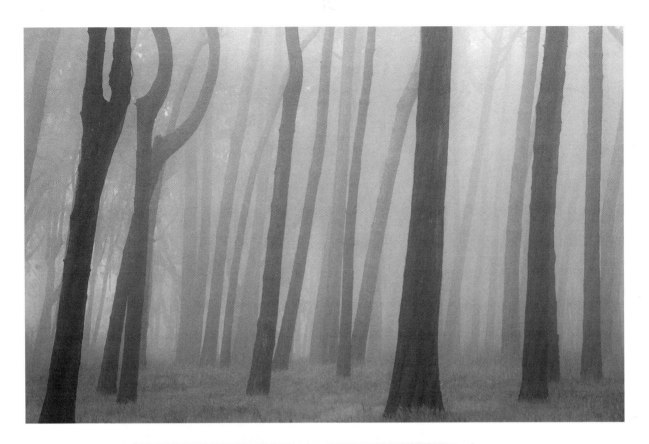

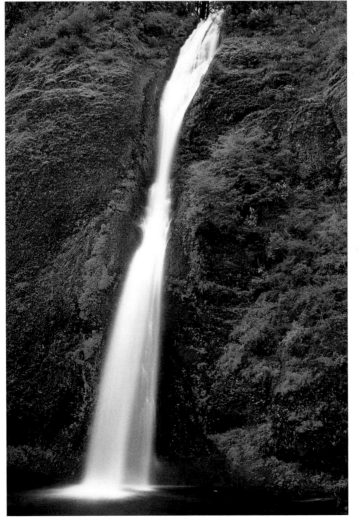

Above: CYPRESS FOREST, SAN FRANCISCO, CALIFORNIA. Canon EOS-1n, 80–200mm lens, Fujichrome Velvia. *Vertical framing might have accentuated the height of the trees, but with horizontal framing I kept out the clutter of branches and brought out the strength of the repeated lines.*

Left: HORSETAIL FALLS, COLUMBIA RIVER GORGE, OREGON. Canon EOS-1n, 28–70mm lens, Fujichrome Velvia. *The long plume of water over this cliff produced a strong line that was not a true vertical. I framed the scene vertically, though, to accentuate the line and the height of the cascade.*

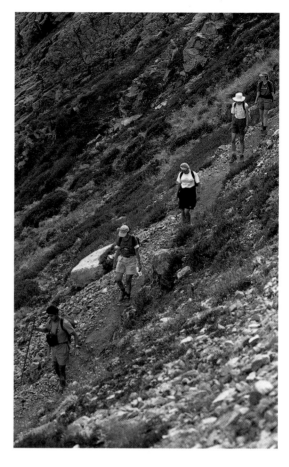

DIAGONAL LINES

If you compose an image in such a way that a slender, vertical blade of grass appears diagonally, the grass expresses more energy. Likewise, the letter Z has a dynamic energy to it, and it is the diagonal line connecting the two short horizontal lines that creates that energy. The angles in architecture make a building appear strong; the slope of a dune possesses more tension than a flat sea of sand.

Diagonal lines express more energy than horizontal or vertical lines do and they move the eye through a scene more rapidly. They represent movement because they look like vertical lines that are falling over. Visual tension develops because the line has been "knocked" out of a balanced state. The resulting instability stimulates the eye and brain. All of this can translate into dynamic energy in a photograph.

However, because diagonals are so aggressive, they can dominate or even interfere with your composition. When a diagonal line enters the scene at one corner and leaves at the opposing corner, it bisects the photograph and imparts the same static feeling you get when you divide a photograph vertically or horizontally. A diagonal line that touches the top or bottom of the frame and one side of it also slices off a section of the image. Once, when I was photographing a green hillside with graceful old oak trees, I had a problem with the unbroken slope of the hill. No matter where I placed the slope in the frame, it cut the picture into two triangles. I couldn't focus attention onto the hillside of trees and rocks. Diagonal lines can be fantastic design elements in your photograph, but like any line, they demand thoughtful incorporation.

Above, left: KETCHIKAN, ALASKA. Canon EOS-1n, 80–200mm lens, Fujichrome Provia 100F. *While waiting to board a boat, I wandered the docks. A cruise ship provided a great study in diagonal lines.*

Above, right: HIKING THE NORTH CASCADES, WASHINGTON. Canon EOS-1n, 75–300 IS lens, Fujichrome 100. *The diagonal line implied by these hikers, along with the diagonal plane of the hillside, accentuates the steep trail and gives the composition a dynamic feeling.*

Facing page: ACADIA NATIONAL PARK, MAINE. Canon EOS-1n, 100mm macro lens, Fujichrome Velvia. *I intentionally angled the camera to place the branch on a diagonal, creating more energy. Because some leaves have fallen over the branch, the eye stays within the frame rather than being visually drawn off the edges.*

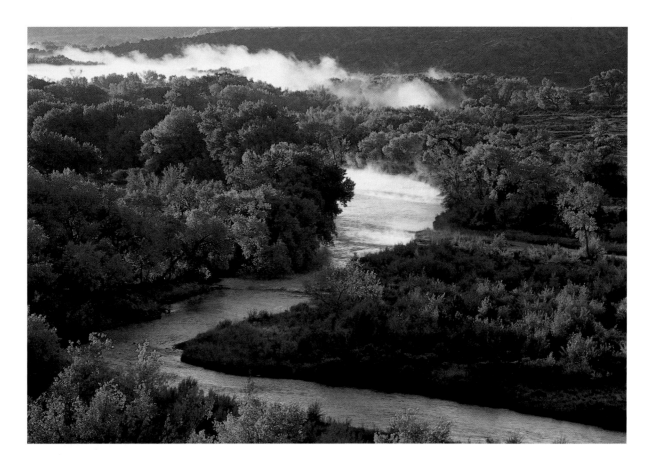

CURVING LINES

Mother Nature didn't make too many straight lines, at least not perfectly straight ones. A curving branch, a meandering river, an undulating road, flower blossoms, and the human form are all made up of organic, curving lines. When architects want to emulate nature, they incorporate curving lines in their structures. These curves convey gentleness and sensuality. We move through an image easily when traveling along a line that curves. The movement is peaceful and unhurried, evoking a feeling of going with the flow.

If you want to create images that are restful and yet have movement, try incorporating curving lines. To make a curving line effective in your photograph, you need to allow enough space for the curve to unfold, to swing back from one direction to another, and to undulate through your scene. Cropping too tightly can prevent the curve of a line from developing, and cutting off the curve of the line with the frame's edge can interrupt the fluid movement of the line.

Try this assignment: Spend a day looking for lines in the world around you. You can choose one type of line, or look for all types. Whichever you select, create interesting compositions in which the line is the subject. Then create compositions that emphasize the full attributes of that type of line. Finally, photograph images that use lines to lead you to your subject or through your scene. In the process, you'll learn to see lines everywhere and to use them to create dynamic photographs. And you'll come to understand the power of lines as an important design element.

CHAMA RIVER, NEW MEXICO. Canon EOS-1n, 80–200mm lens, Fujichrome Velvia. *On assignment in northern New Mexico one cool morning, I photographed the river as the sun and the mist rose and the cottonwoods glowed with backlighting. The elevated viewpoint allowed me to accentuate the S-curve of the river, giving the photograph a relaxed, pleasant mood.*

SHAPE

We identify many objects by their shapes alone, long before we've seen their color, texture, or other details. Shape is a fundamental element of design. Yet when it comes to making a photograph, it's surprising how photographers often forget to take the importance of shape into account, even when many shapes are present in a scene.

Shapes possess strong symbolism, and the shapes that dominate your photographs will dictate their tone or feeling. Squares and rectangles represent stability and structure. We don't often see a square or rectangular object in the natural world, except, perhaps, in crystal and rock formations. In the man-made world, however, squares and rectangles are ubiquitous, in office buildings, packing boxes, tractor trailers, and barns—they're all around us. When a photographer includes a square or a rectangle in an image, the photograph can suggest a sense of structure.

Triangles represent strength and endurance. Consider mountains peaks, among the few places in nature where triangles appear naturally. Wide at the base and pointing heavenward, they represent stability and focused energy.

CATHEDRAL, MORELIA, MEXICO. Canon EOS-1n, 80–200mm lens, Kodak E100S. *Traveling with family can be a challenge when trying to make great photographs, but in this case I never had to leave the hotel room. Right outside my third-floor window, the sunrise set the clouds on fire, defining the strong shapes of the cathedral's towers.*

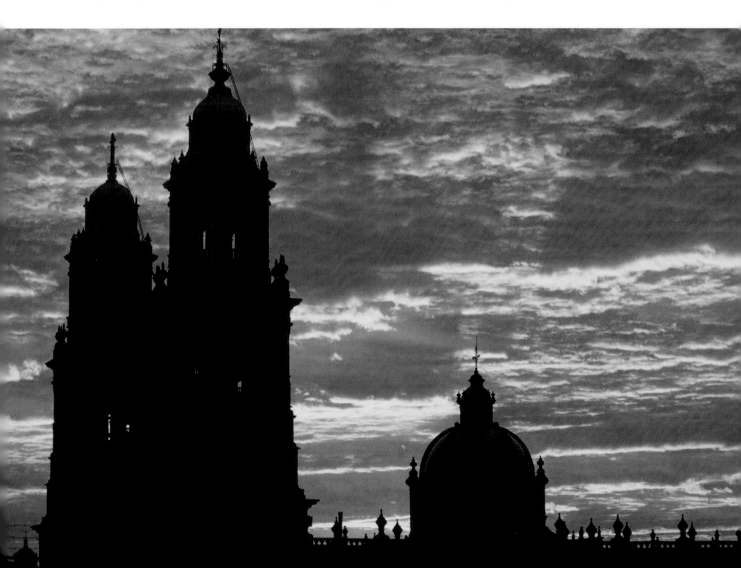

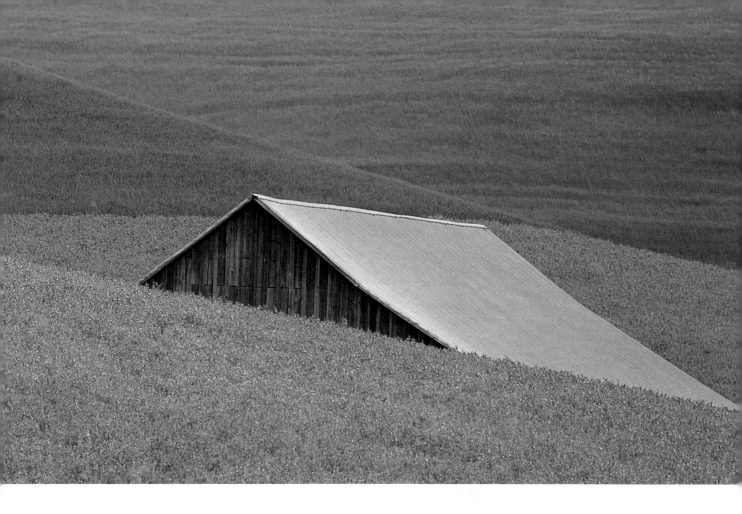

Circles, composed of single, unbroken lines, represent wholeness. The earth is surrounded by its circular atmospheric boundaries, and a pond is a circle retaining water within its edges. The planets, the sun, and the moon are the most powerful circular shapes in nature, but sand dollars, dewdrops, berries, and flower blossoms are circles, too.

Shapes become visible when you frame a composition. All the sky that sits at the top of your image when you're out photographing landscapes is a shape once it's defined by the edges of the view-finder. The green field below the sky is another shape. These shapes may be rectangular, triangular, or something more organic. You can modify them by altering your position or the angle of the camera. When making a landscape photograph, try tilting the camera down, and the shapes of

the sky and land will change, with the shape of the land becoming dominant. Tilt the camera up, and the shapes will change again, with the shape of the sky now becoming dominant. The negative and positive spaces of your pictures are actually shapes, too, just as important as the shape of your subject. When you learn to see these shapes, you can control the balance between them and your subject, creating a stronger composition.

In your photographs, frontlighting and backlighting will define shape. Most professional photographers avoid frontlighting shapes, because the resulting image can be flat and dull. Frontlight can also illuminate a great deal of detail, which takes the emphasis off the shape. However, backlighting an object to produce a silhouette allows you to achieve a graphically pleasing study of a shape.

Above: PALOUSE REGION, WASHINGTON. Canon EOS-1n, 500mm lens, Fujichrome Velvia. *The silver roof of a barn nestled between the green hills grabbed my attention as I rounded a bend on a country road. I saw the fields as repetitive green triangles that echoed the triangular shapes of the barn's siding and roof.*

Facing page, opposite: BARN SILO, WASHINGTON. Canon EOS-1n, 80–200mm lens, Fujichrome Velvia. *The silo and the complementary silvery blue tin roof of the barn create strong shapes against the blue sky. I chose to frame the silo vertically to emphasize its structure. I hadn't planned for the bird, which was a nice addition.*

FORM

How do you know that a tree is round? The light illuminating the tree defines its form. The gradual shift of tones from highlight to shadow, known in painting as chiaroscuro, gives dimension to the tree. Without that light, the tree might appear to be nothing more than a cardboard cutout when you capture it on film.

Strong sidelight is usually best for illuminating form, but even in diffuse light, you can show enough shading to define form. When light is very even, or flat, shadows and shading disappear, as does the form of an object and the suggestion of depth.

As an exercise to learn how to see shape and form more readily, select an object outdoors and photograph it under specular and diffuse light and using all three directions of light (see pages 26–29). Or the next time you head outdoors to photograph, make it a point to notice how many different shapes or forms appear in a scene you are composing. Pay attention to the empty areas of an image, because they are shapes, too.

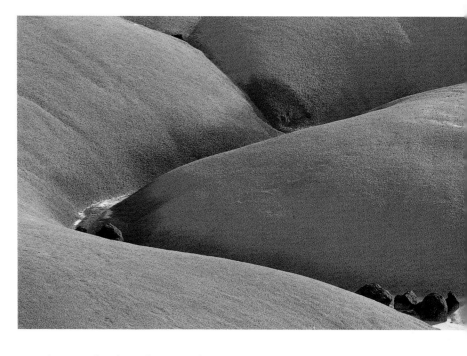

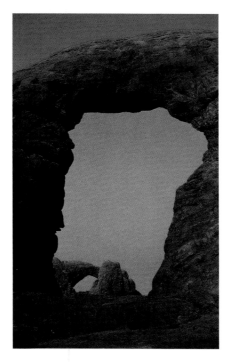

Above: BENTONITE HILLS, CAPITOL REEF NATIONAL PARK, UTAH. Canon EOS-1n, 300mm lens, Fujichrome Velvia. *When I put on my 300mm lens to "scan" the area, I spotted these softly rounded mounds of bentonite clay. Soft light enhanced the pillow-like forms, and the telephoto lens visually brought the mounds closer together and emphasized the diagonal of the wash. The small rocks at the right keep the viewer from running out of the frame.*

Left: TURRET ARCH AND NORTH WINDOW, ARCHES NATIONAL PARK, UTAH. Canon A2, 80–200mm lens, Fujichrome Velvia. *The organic shapes of the twilight blue sky contrast sharply with the arch formations in this image and become just as important to the composition as the arch itself.*

PATTERN

Pattern is everywhere in the natural and manmade world. Take a moment and look around you. How many patterns do you see right now? No doubt, many.

Pattern forms when such elements as shapes, lines, or colors repeat within a scene, and it amplifies the significance of each individual element. When you have three or more similar elements in your image, a pattern emerges. But I've never found that just three rocks, trees, or blossoms, or three of anything else, create a strong pattern, even if they are identical. By the same token, an image filled with a variety of patterns can lose impact. But an image of, say, a field of wildflowers in which only one or two types of flowers are repeated in your frame can be very strong.

A pattern grows in visual strength when it fills the frame, as the mind's eye assumes that the pattern continues beyond the edges. If I photograph a small area of leaves on the ground in a desert wash, I make sure I compose so that the leaves extend beyond the frame, implying there is more than meets the eye. On the other hand, I am less concerned about extending a pattern beyond the edge of a frame if I am creating a large scenic or landscape; the pattern still adds interest to the scene.

Any focal length lens will work to photograph pattern. I use everything from a wide-angle to a macro lens when I am photographing close-ups or intimate landscape patterns. When I want to extract a

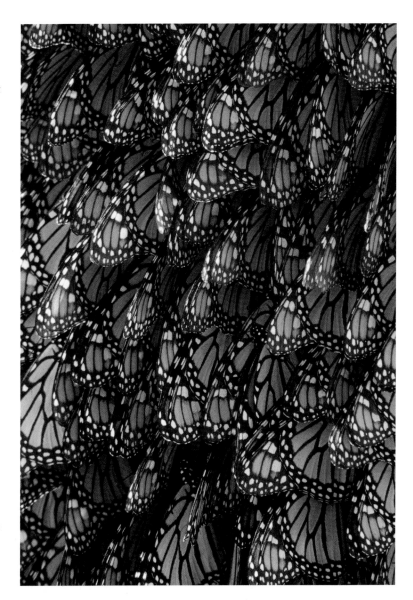

pattern that is part of a distant scene, I use a telephoto lens.

An image of solid pattern can have impact, but the eye can tire of viewing a pattern repeatedly. If you want to avoid monotony, include something in the image to break up the pattern. The anomaly provides a point of contrast and a place for the eye to rest before jumping into the pattern again. True pattern is random and the eye doesn't follow a set

MONARCH BUTTERFLIES, MEXICO. Canon EOS-1n, 300mm lens, Kodak E100S. *The wings of tightly clustered monarchs created a beautiful pattern in a butterfly reserve in central Mexico. By filling the frame with the pattern and cropping into some wings at the edge, I have suggested there are more than just these few. In fact, there are millions more, on every surface in the forest.*

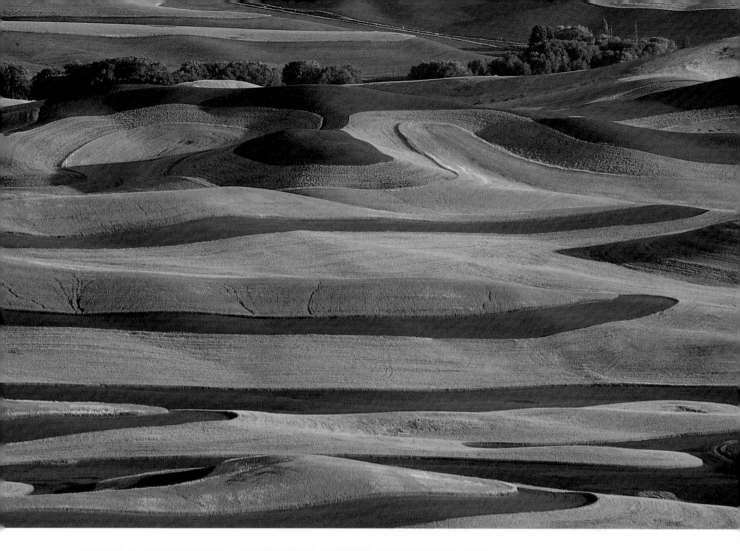

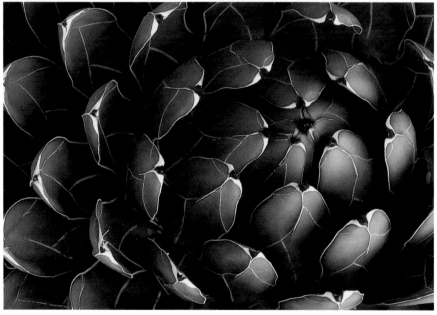

Above: PALOUSE FARMLAND, EASTERN WASHINGTON. Canon EOS-1n, 80–200mm lens, Fujichrome Velvia. *Different color fields create a patchwork pattern in this agricultural landscape. Because the bands of colors recede, the pattern seems to move toward the background.*

Left: QUEEN VICTORIA AGAVE, ARIZONA. Canon EOS-1n, 90mm tilt-shift lens, Fujichrome Velvia. *When I diffused the light on this agave, the pattern really jumped out. In this image, the pattern seems to move out from the center of the plant, suggesting that it's unfolding right before you.*

course when viewing it. However, wide-angle lenses can create a feeling of direction, since objects close to the camera recede in size toward the background, making it appear that the pattern is moving. When pattern begins to take on direction or movement, it creates rhythm, which is covered later in this book (see page 96).

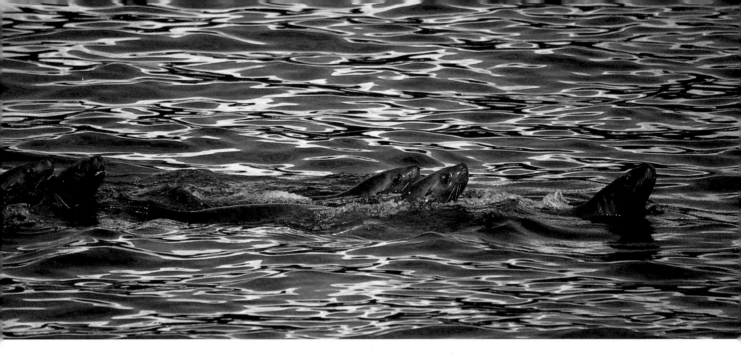

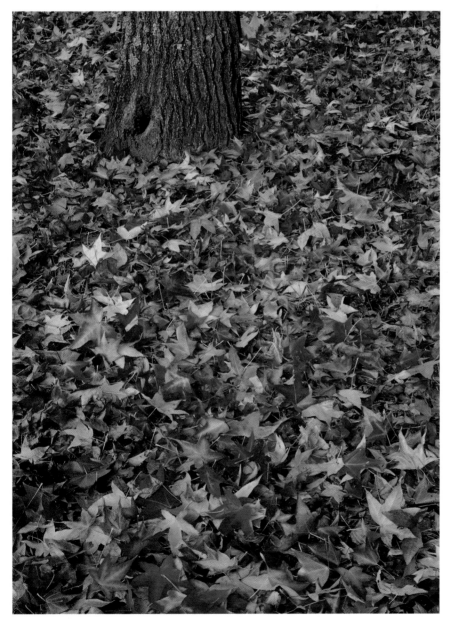

Above: STELLER'S SEA LIONS, ALASKA. Canon EOS-1n, 300mm lens, Fujichrome Provia 100F. *Curious sea lions broke up the wild pattern of the water's surface, giving the eye a place to rest between the waves of color in the scene.*

Left: AUTUMN LEAVES, MARIN COUNTY, CALIFORNIA. Pentax 6x7, lens unknown, Fujichrome Velvia. *Including even just a small amount of the tree in the composition breaks up the pattern of the leaves and helps tell the story of where they came from.*

TEXTURE

Touch is an important human experience. The memory of how something feels can reside indefinitely in your mind. As children, we learned a lot about texture while touching everything around us. We walked and crawled on wood, carpet, and concrete. We touched fabrics, such as the flannel of pajamas, the cotton of shorts, or the satin of dresses. We played with sand, and probably with wooden toys, and we learned what "wet" and "dry" felt like. We all recall certain textures, like a mother's hair or the fur of a favorite pet. It's no wonder that a photograph of texture can evoke a strong response. The more dominant the texture is in the picture, the more likely it is to evoke a response.

You need the contrast of light and shadow to record texture. Light striking a subject from an angle accentuates the surface, defining all its bumps, hairs, or ridges. If the light is strong and low, the texture will be more pronounced in your photograph. Using this type of light, for example, you can show the roughness of sandstone or the coarseness of weathered wood to create a photograph with a greater visual dimension. Diffuse light often works better for softer textures. If you want to show the softness of a meadow of grasses, for instance, you should probably choose "soft" light. There is an appropriate way to use lighting to emphasize each type of texture, and by looking at how different types of light affect textures

MOSSES, GLACIER NATIONAL PARK, MONTANA. Canon EOS-1n, 100mm macro lens, Fujichrome Velvia. *These tiny mosses were very soft to the touch. To capture that feeling of softness, I used the diffuse light of a cloudy day and came in very close with my macro lens. What a nice, soft bed it would make for a field mouse.*

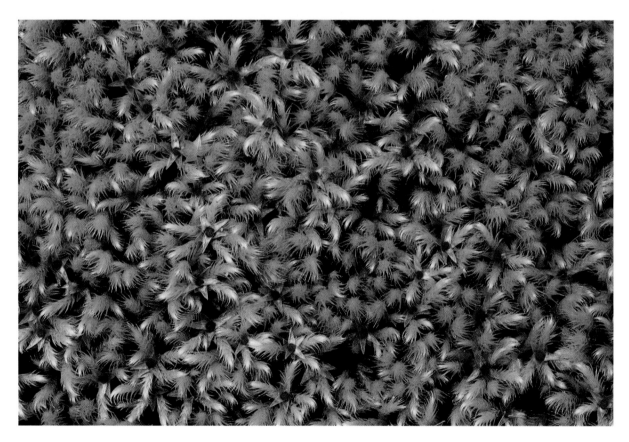

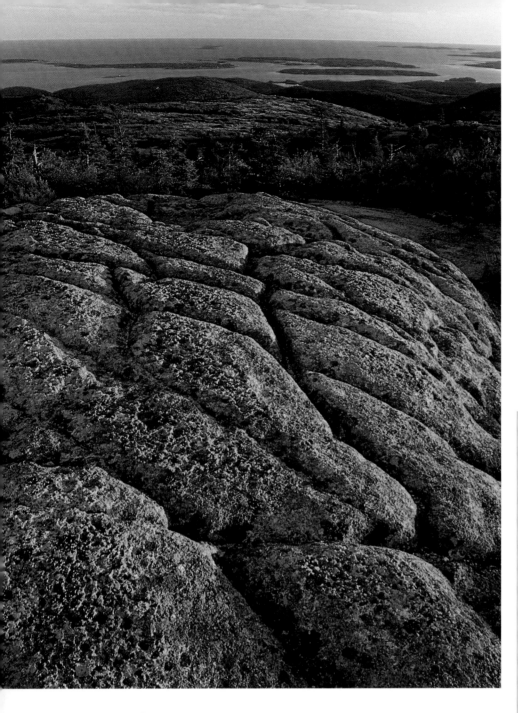

Above: CURLED MUD, MOJAVE DESERT, CALIFOR- NIA. Canon EOS-1n, 100mm lens, Fujichrome Velvia. *Soft sidelight emphasizes the curls and adds dimension to convey the texture of this drying mud.*

Left: CADILLAC MOUNTAIN, ACADIA NATIONAL PARK, MAINE. Canon EOS-1n, 20–35mm lens, Fujichrome Provia 100F. *Eons of glacial scraping scarred this granite out- cropping. The low angle of the afternoon sun skimmed the surface of the rock, bringing out a rough- ness that you can "feel."*

you'll arrive at the right way to pho- tograph them.

You can imply texture in a pho- tograph. When I look at an aerial photo in which good sidelighting emphasizes the ridges and valleys, I sense what I would experience if I could touch the earth's surface.

You can produce an effect of texture by using high-speed films to emphasize grain, especially when you push the film two or three stops. My favorite old films, Scotchchrome and Agfachrome, both with ISOs of 1000, were terrific for emphasizing grain, but they are no longer pro- duced. Most manufacturers have tried to eliminate grain in their films, but some of the higher-speed slide films will still show grain when pushed or when agitated dur- ing the developing process.

By now you are probably seeing lines, shapes, patterns, and textures everywhere, and that's the first step to creating photographs that contain strong visual design.

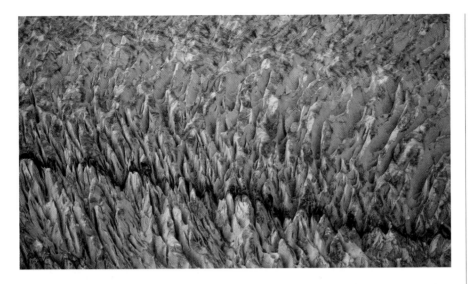

Left, top: SAWYER GLACIER, ALASKA. Canon EOS-1n, 28–70mm lens, Fujichrome Sensia. *The surface of the Earth fascinates me. I photographed the rough, jagged surface of the top of this glacier while flying about 1,000 feet above it.*

Left, middle: BOULDER MOUNTAIN, UTAH. Canon EOS-1n, 300mm lens, 1.4 extender, Fujichrome Velvia. *Diffused backlighting created the soft texture of this hillside of bare aspen trees. As each branch overlapped with others, the trees blended into an implied softness.*

Below: MENDOCINO, CALIFORNIA. Canon A2, 28–70mm lens, Agfachrome 1000 rated at ISO 2000. *A foggy day, combined with high-speed film, created an implied texture. Pushing film increases noticeable grain, which enhances the effect.*

THE DYNAMIC
IMAGE

It's all about translating a three-dimensional world into two dimensions while still expressing depth. —ANONYMOUS

Good light and interesting design elements do not in themselves ensure you'll make a good photograph. You must figure out how to get this light and these design elements onto film in a pleasing composition that has depth and drama. If you are not in control of perspective your image will lack depth. If you don't create a strong composition, your image will consist of chaotic, confusing elements. And if you don't know your lenses well, you may not utilize their potential to help you present your scene in the most dramatic way. The goal is to create powerful images without consciously thinking about composition and perspective. Once these become intuitive, you can devote your energy to creativity. The next two chapters will help you master perspective and composition and teach you how to use your lenses to their best advantage.

HIKING DOWN TO GRIESALP, SWITZERLAND. Canon EOS-1n, 28–70mm lens, Kodak EPP. *The line of people receding and shrinking in apparent size makes the perspective evident here. Since the brain assumes they are all similar in height, it registers distance between the people in the foreground and those in the background.*

GAINING PERSPECTIVE

Perspective, the way objects relate to one another spatially and to the lens, gives dimension to a photograph. Images that incorporate perspective have greater visual impact. Perspective makes objects in the foreground appear to be closer than those in the background—in short, perspective lends depth to a photograph, though this depth is only an illusion, since film is two-dimensional.

The only way to alter perspective is to change your position, or point of view. If you view a scene through six different focal lengths without changing your position, the perspective remains the same. When you change focal lengths, you are simply changing the framing, not the perspective. To see how changing your position changes perspective, try the following exercise: Find a scene that has an object you can get close to and a background with a mix of elements. For example, you might choose a friend sitting on a park bench backed by trees. As you move closer to your friend, notice what happens to the relationship between the person and the trees in the background: Your friend appears much larger, while the background shows little change in size. However, note that the background objects have changed position in relation-

ALMOND ORCHARD, CENTRAL CALIFORNIA. Canon EOS-1n, 80–200mm lens, Fujichrome Velvia. *The rows of planted trees in this orchard appear to grow closer together as they recede into the distance— the effect of apparent perspective.*

ship to your friend because you altered the perspective as you moved into the scene.

Take the results of this exercise and apply it to a landscape, say a meadow. Depending on where you stand in the meadow, the elements will take on a different appearance and their relationship to one another will appear to be different. Because of this, you need to find the best point of view from which to express the depth you want your photograph to have. When you arrive at a location, walk around your scene with one eye closed (that's the way the camera sees) and watch how dramatically the relationship between objects and their relationship to the background changes. Get higher or lower, if possible, to see what this does to the perspective. At some point, you'll feel the scene come together, and you will have found the best position for what you want to emphasize.

I always prefer to take time to get to know a landscape I photograph. Over the years I have come up with

a certain way in which I approach any scene, and I have a "what's important here" list of questions I always run through. These questions help me assess a location more quickly. They are especially handy on those occasions when circumstances cause me to arrive somewhere just before the light becomes good and there isn't time to walk around the area slowly to find a point of view that is pleasing, one that emphasizes what I find important.

WHEEL FENCE AND FARM, EASTERN WASHINGTON. Canon EOS-1n, 50mm lens, Fujichrome Velvia. *Using my 50mm lens, I altered the perspective in these two images by changing my position. The fence was visually interesting, but in the lower photograph it lacked visual strength. In order to emphasize the fence, I moved closer and chose a more oblique angle of view. The second photograph (above, top) has more impact because the main subject becomes the fence.*

DEFINING DEPTH WITH
SELECTIVE FOCUS

You can alter apparent perspective, or the appearance of depth, by using selective focus on your lens. A sharply focused subject will appear closer than anything that is not sharp in the picture. For example, you can use selective focus to make a particular tree stand out in a forest grove. Otherwise, the tree falls into the same visual plane as the other trees and becomes just another element of the forest. When you separate the plane of the tree from the forest behind it, you create a sense of depth, implying that the tree is significant.

You can use any focal length lens to focus selectively on an object. The secret is to select an aperture that creates an out-of-focus background. Telephoto lenses make this easy, but you can also use a wide-angle lens to selectively focus when the subject that you want to be sharp is very close to the lens. Remember that the degree to which your background is out of focus depends upon your distance to the subject and the subject's distance to the background. Use your depth-of-field preview button to check whether the effect is what you want.

Above, left: DAISIES, CALIFORNIA.Canon EOS-1n, 90mm tilt-shift lens, Fujichrome Velvia. *I used a 90mm tilt-shift lens to compose a "near-far" relationship. By making the foreground daisy large, I've implied a distance between it and the background daisies. The selective focus also adds to the feeling of depth.*

Above, right: RED BOW, COLORADO. Canon A2, 80–200mm lens, Kodachrome 64. *To give this image a feeling of depth, I focused on the red bow and chose an aperture that would allow the rest of the fence to recede into soft definition.*

A DIFFERENT POINT OF VIEW

Have you ever considered what a chipmunk's view of a meadow would be? How would a field mouse view a church? What might an eagle's view of a valley or meandering river be? How does the world look from the height of a two-year-old child? Each of these viewpoints offers a whole new way to see the world, and you can create expressive images that highlight these points of view.

Of course, this approach means you'll have to give up any vestige of self-consciousness. Get over it! I've been on the ground in dozens of places around the world, and it's worth it. Whenever I travel, I always try to get overhead views from bell towers or mountaintops. I take scenic flights to create aerial points of view. Aerials provide a

tremendous sense of place, and this is often important when I am working on a story or rounding out my stock coverage.

Left: BODEGA, CALIFORNIA. Canon EOS-1n, 20mm lens, Fujichrome Sensia. *Wanting to suggest the concept of "looking heavenward," I got close to the church with my wide angle lens to distort and enhance the sense of the building's height.*

Below: MUSHROOM, GLACIER NATIONAL PARK, MONTANA. Canon EOS-1n, hand-held, 100mm lens, Kodak E100S. *Ever wonder what a mushroom might look like to a field mouse? To capture this view, I got down on my belly and began to look around. My point of view makes the image more intimate and more exciting than it would be if I were looking down on the mushroom.*

Above: LAUTERBRUNNEN,
SWITZERLAND. Canon EOS-1n,
28–70mm lens, Fujichrome
100. *I actually made this "aerial
perspective" from a cliff-hanging
trail high above the village.
Using a wide focal length, I
accentuated the feeling of height
by distancing the village even
more. The view through the sur-
rounding clouds adds to the feel-
ing of being in an airplane.*

Left: GOLDEN GATE BRIDGE,
SAN FRANCISCO, CALIFORNIA.
Canon EOS-1n, 28–70mm
lens, Fujichrome Velvia. *I am
always looking for unusual light
and framing opportunities to give
a new view of a subject. Framing
the bridge with a stand of cypress
trees allowed me to add a feeling
of depth to the image.*

The next time you are "in the
field," unleash your imagination and
see what a new point of view can do
for your photographs. Your results
are limited only by the extent of
your curiosity and your willingness
to try new ways to see.

To create more dynamic out-
door photographs, use the charac-
teristics of perspective to describe
relationships of size and depth.

Move in close on an object to exag-
gerate its size in the frame com-
pared to the background elements.
Try framing a background subject
with a foreground element to give
your image a greater feeling of
depth. Once you understand the
power of perspective, and how to
alter it, you have another creative
tool for giving your images greater
visual depth.

HOW LENSES SEE

A lens changes the way you see the world, from an expansive view to a close-up look at a particular detail.

WIDE-ANGLE LENSES

Wide-angle lenses are powerful optics that, in the hands of an accomplished photographer, can create dynamic images. My 20–35mm is one of the most-used lenses in my bag, but many amateur photographers use a wide-angle lens simply to capture a grand vista or to compensate for the fact that they can't move back far enough to get what they want in the picture. When the wide-angle lens is used this way, it's no wonder that so many photographers lament their ability to use it effectively. When I ask students in my workshops what they were trying to accomplish using a wide-angle lens, I often get responses like, "Well, I liked the stream on the left, and the trees on the back right were interesting, and the coyote in the middle was great, and, oh, the lichen on the rock in the foreground was really nice, too . . ."

You get the picture. Without conscious control of composition or perspective, your effort with a wide-angle lens can result in a cluttered image in which the main subject is indistinguishable from the rest of the scene. If you put it *all* in the photograph, how will your viewer be able to identify the main subject in the final image?

A wide-angle lens expands the appearance of depth and presents you with a large foreground area that you must use creatively to make the photograph work. You'll usually need to move closer to objects once you have put on the wide-angle, in order to increase foreground interest. A bed of flowers, a single interesting plant, or rocks with lichens may be all you need to fill that foreground space, but if you

SPICE VENDOR, CAIRO, EGYPT. Canon EOS 3, 28–135mm IS lens, set at 28mm, Kodak E100SW. *This spice vendor was not very busy when I stopped to photograph his display. I tilted the lens downward to emphasize the cloth sacks of spices, making them more dominant than the vendor, but he and his signs remain to give the image a sense of place.*

don't fill it, the empty space in the foreground will dominate your composition.

To get your message across, you sometimes have to exaggerate things, but creative photography is all about dramatic presentation. Wide-angles are great for presenting your subject or scene dramatically. In the desert Southwest, I often use my wide-angle to capture a wide expanse of winter skies, which can be brilliant canvases of color. By tilting the wide-angle upward, I can increase the emphasis on the sky. If I want to emphasize a meadow of wildflowers, I tilt the lens downward to exaggerate the meadow's size and increase its importance in the frame.

Because wide-angles can emphasize objects close to the camera and still take in a broad scope of background detail, they can dramatically present something in the foreground. If you bring your lens close to an object and tilt it downward, the object becomes a visual stepping stone, inviting the viewer to participate in your scene more intimately. This is a classic way to create expressive landscapes, ones that not only show off interesting foreground objects but also express great depth.

While traveling through Yosemite National Park one summer, I stopped for a break at Olmstead Point, a well-known overlook with a much-photographed view. I gave myself the challenge of finding an unusual way to show the glacial boulders and granite slabs that are a hallmark of the point. Walking around, I discovered an area where the long fracture lines in the granite led the eye back toward Half Dome in the distance. I reached for my 20–35mm, knowing

Facing page: BRIDGE OVER THE LUCERNE RIVER, SWITZERLAND. Canon EOS-1n, 20–35mm lens, set at around 20mm, Fujichrome Velvia. *The foreground-background relationship creates a feeling of depth and adds a graphic quality to the image. Had I just photographed the distant row of buildings, the picture would have less depth to it.*

Below: HARVESTED HAY, TUSCANY, ITALY. Canon EOS-1n, 20–35mm lens, set at 24mm, Fujichrome Velvia. *By placing a bale of hay close to the camera and using a wide-angle lens, I was able to create a strong feeling of perspective and depth as the other bales receded into the distant landscape.*

it would exaggerate the foreground-background relationship. As I got down low and angled the lens downward toward the rock's surface, the fracture line became distorted, visually growing in size and pulling me strongly through the scene. Because wide-angles have such a deep depth of field, I was able to get close to the foreground while keeping the background in focus by using a small aperture of f/22 and the hyper-focal settings on the lens. (Note: Even though a wide-angle lens has a great depth of field, it still makes sense in extreme depth situations to set the hyper-focal focus. Since most of the lenses I carry today don't have hyper-focal marks, I now pack along a small hyper-focal chart as a guide.)

If you can't get both foreground and background in focus, you'll have to choose between them. For most landscapes, it's more pleasing to the

eye if the foreground is sharp and the background falls into softness. When I'm assigned an environmental portrait, I often use my wide-angle to get in close to the person while emphasizing their surroundings, too. Having the person up close creates a sense of intimacy; the

Above: DAIRY COW, SWITZERLAND. Canon EOS-1n, 20–35mm lens, set at 20mm, Fujichrome Sensia. *I got as close as I dared to this cow for a humorous, distorted portrait.*

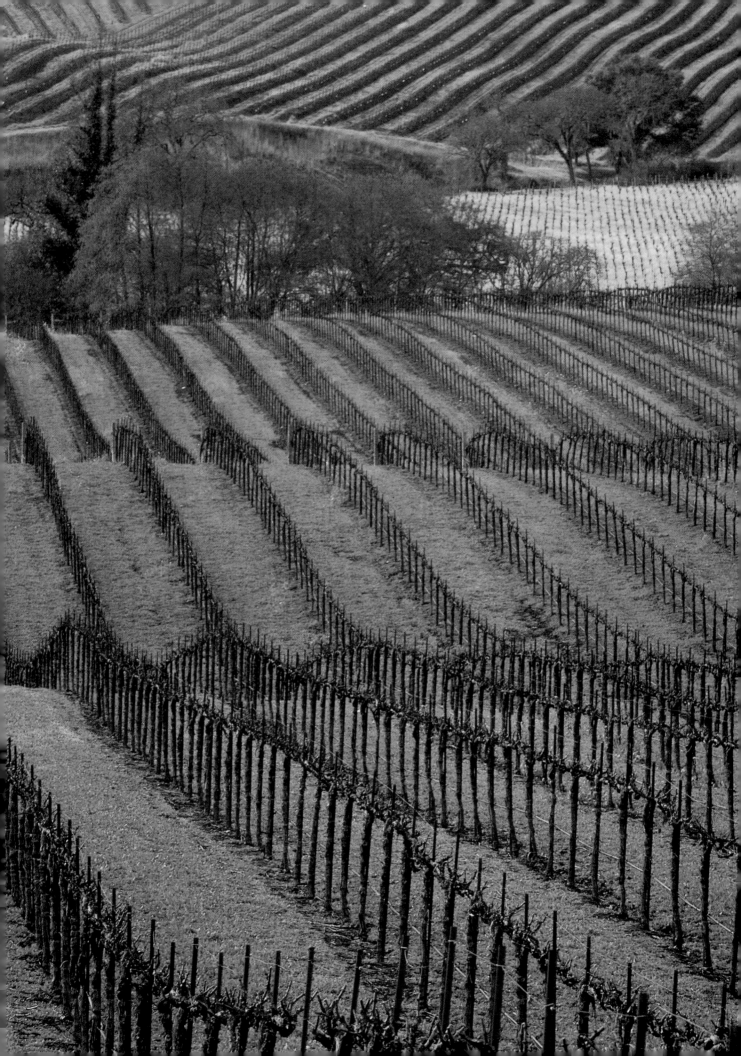

photograph is more appealing visually and tells more of a story, too.

With a wide-angle, you can frame a background object with a foreground element or emphasize a bridge railing or fence while keeping the background in focus, to express depth. You can also take advantage of a wide-angle's distortion to accentuate leading lines—whether it's a trail, a river, or a fence—and visually draw your viewer into the scene.

The best way to learn how a wide-angle lens "sees" is to put one on your camera and begin looking. Move in, out, and around your scene to view the potential that the lens has to offer.

NORMAL LENSES

Normal lenses are called "normal" because they render a scene so it looks much the way the human eye sees it, with spatial relationships appearing realistic and objects appearing as their normal sizes. Normal lenses range from 45mm to 65mm in focal length for 35mm. In the days before zoom lenses, many photographers tried to make outstanding pictures with normal lenses. Unless they applied the concepts of perspective and good composition, however, most made mediocre pictures, giving the normal focal-length range a bad reputation. Many creative photographers today will tell you that the 45–65mm range produces boring pictures. This is really not true! Henri Cartier Bresson used only a 50mm lens, and his images are not boring at all. As photographer Ernst Haas said, "It's the photographer's creativity, and not the equipment,

that ultimately produces the photograph."

While normal lenses are limited in their ability to exaggerate perspective, you can still create strong compositions if you learn how normal lenses "see" the world. To prove that you can make wonderful pictures in the normal focal length, dust off your old normal lens or tape a zoom lens into the normal range, and expose at least one or two rolls of film. Push yourself to make interesting compositions. You can do it.

Above: SODA BUTTE CREEK, WYOMING. Canon EOS-1n, 28–70mm lens, set at 70mm, Kodak E100S. *I used a relatively normal focal length to create this quiet winter scene.*

Facing page: WINE COUNTRY, NORTHERN CALIFORNIA. Canon EOS-1n, 28–70mm lens, set at 28mm, Fujichrome Velvia. *The rows of grapevines and the bands of green grass provide leading lines that draw you into the background and up the hill.*

TELEPHOTO LENSES

There is magic in bringing the details in distant and inaccessible scenes closer, or in bringing wildlife visually closer without risking life and limb or stressing the animals. I'm always delighted when I look through "long" lenses, as they offer a perspective that can't be seen with the normal eye. Using telephoto lenses, I've had the wonderful opportunity to see the red lining inside a pigeon guillemot's mouth when it begins to sing. I've watched a mother hummingbird feed her tiny hatchlings. Once I thought an elk in rut was charging me, but when I took my eye away from the viewfinder, he was a hundred feet away and his interest was in a nearby female elk. It's the chance to have experiences like these that make telephoto lenses so popular with outdoor photographers.

Within telephoto lenses there is substantial difference in focal lengths: Any lens in the 100mm to 1200mm range is considered a telephoto. The shorter the focal length, the wider the angle of view and the less optical compression there is. As the focal length increases, the field of view narrows, reaching into the scene to extract the details. Optical compression is stronger, flattening the appearance of depth. A row of trees can look very close together, when they might be 30 feet apart. The longer telephoto lenses (300mm or longer) can make a flock of 200 flamingoes look like a thousand by visually "stacking" the birds tightly together. While this may not be realistic, it is artistic.

When you compress elements with a telephoto lens, graphic pat-

terns can develop. You can photograph the pattern of birds in flight or a mosaic of autumn-hued trees on a hillside. The narrow field of view isolates the pattern from its surroundings and creates a graphic, uncluttered composition. Because telephotos lenses have such limited depth of field, they are wonderful for photographing wildlife and bird portraits when you want the background to become just a wash of color, with the animal standing out in the image. Depending upon the magnifying power of the lens, the

Top: BODIE STATE HISTORIC PARK, CALIFORNIA. Canon EOS-1n, 300mm lens, 1.4 teleconverter, Kodak E100S. *The ghost town of Bodie was larger at one time. I used a telephoto lens to make the buildings appear much closer together than they really are.*

Above: ALDER TREES, NORTHERN CALIFORNIA. Canon EOS-1n, 300mm lens, Kodak E100S. *A telephoto lens optically compressed this stand of alder trees, creating a tapestry effect.*

After many years of photography, I can see with my eyes the potential a scene offers for using a telephoto. Nonetheless, I am always pleased when I look through the lens. I often put one on the camera just to have a look around, because the effect a telephoto lens has on a scene can be a wonderful surprise.

A final word about lenses: Many photographers who use zooms don't have a clue which focal length they used to make their photograph. Does this matter? To a degree, yes. In order to be fast in responding to changing conditions, you need to quickly choose the right lens from your bag. Knowing what you need can make the difference between getting the photograph and missing it.

compression can also eliminate any suggestion of depth between the elements, resulting in a tapestry effect.

Left: BARN OWL (controlled situation). Canon EOS 3, hand-held, 300mm lens, Fujichrome Provia 100F, with fill-flash set at −1⅓. *By getting close to the owl and using selective focus and a wide aperture, I was able to transform a visually cluttered background of shrubs into a pleasing wash of color behind the bird.*

Below: COYOTE, SOUTHERN ARIZONA. Canon EOS-1n, 300mm lens, with 1.4 teleconverter, Fujichrome Velvia. *I wanted to show the coyote in its habitat, so I chose an aperture that would yield some background detail to suggest its environment.*

CREATING EFFECTIVE
COMPOS

Good composition is merely the strongest way of seeing.

—EDWARD WESTON

Why does one photograph hold your attention when another elicits only a passing glance? Part of the answer lies in the composition, the way in which all the lines, shapes, and colors are arranged in the picture. The right lens, appropriate f-stop, and correct exposure are very important factors, too, but they are only tools to help you bring all the creative elements of your picture together in a compelling way.

Composition is the art of presenting your vision in an uncluttered, clear arrangement. A great piece of music relies on the thoughtful arrangement of sound and silence. A great photograph relies on the thoughtful arrangement of objects and space. No matter how visually interesting your subject matter is, a chaotic composition will diminish its impact. As the jazz musician Charlie Mingus used to say "Anybody can make the simple complicated. Creativity is making the complicated simple."

The first step in composing a photograph is to develop a clear vision of what you want to say. If you don't know what you find important in the photograph, how is your viewer going to know? Once you have determined that, you can organize the elements in your frame to support your vision. The purpose of composition is to lead the viewer through an assortment of elements and objects that, when combined, tell the story you want to tell. You might want to show an interesting object or convey a mood, a particular point of view, or an impression.

CHURCH AND CLOUDS, MCMARTYS, NEW MEXICO. Canon EOS-1n, 20–35mm, Fujichrome Velvia. *While driving down the highway, I noticed this great old church beneath a beautiful desert sky. Placing the church in the lower third of the frame allowed me to accentuate the great pattern of clouds.*

The human mind craves structure and order, and good composition creates order from visual chaos. As a photographer, your role is to organize your scene with just enough structure to effectively articulate your ideas and feelings.

Good composition is the foundation of every successful artistic image. It's not as simple as pointing the camera straight at your subject. It's not enough to just routinely place your subject off-center in the composition. You have to think about what's dominant in each scene you encounter, and whether the composition is balanced. You have to consider whether the proportion

of objects and spaces is correct. I can hear you exclaiming, "Gosh, if I have to spend time thinking about all of these things, the elk will have moved on to different meadow!" This may be true at first, but an increased awareness of these important composition ideas will have you seeing differently. Before long, seeing in a new way becomes an intuitive process—but only if you first develop the habit of considering these points. When you apply the following ideas of dominance, balance, and proportion, you'll find your compositions becoming simpler yet stronger statements of your own creative vision.

SEA URCHIN, BIRCH POINT STATE PARK, MAINE. Canon EOS 3, 28–135mm IS lens, Fujichrome Velvia. *The gently sweeping lines of the darker sand on this beach drew my eye to the tiny sea urchin shell and the line of kelp. By framing the shell horizontally, I could place it in a strong position and use the lines in the sand to accentuate it.*

A BASIC COMPOSITION FORMULA

The phrase "rule-of-thirds" is used to describe a guideline for composition. Photographers took this rule from painters who had determined that the eye tends to focus on certain areas of a picture. They reasoned that pleasing compositions resulted from dividing the picture into a 2:1 ratio, which produces order and stability in a picture. The formula has become a standard in photographic composition, and you can use it to help make your photographs more harmonious.

Divide your photographic frame into thirds with imaginary lines, both horizontally and vertically. The lines of the grid are good positions to place any strong lines that exist in your scene. For example, place a horizon line one-third in from the top or bottom of the frame. Place a vertical line, such as a flagpole or tree, one-third in from the left or right side of the frame. Place points of interest, objects, or elements where the lines on this grid intersect. This placement commands attention and directs the eye away from the center of the frame, creating a more dynamic composition.

Though this formula provides a helpful guide for creating interesting compositions, don't follow the rule so strictly that your compositions become predictable. It's still important to evaluate what arrangement works the best for your photograph, based on other factors that affect composition. Know when to bend the rules to build dynamic tension in your image.

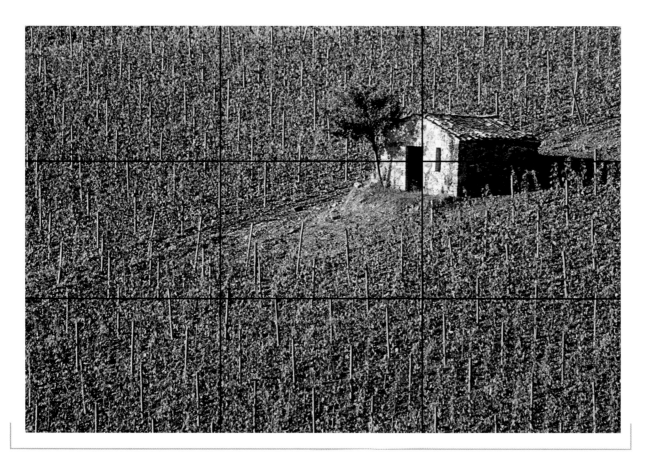

DOMINANCE

If you've ever heard yourself saying, "I don't remember seeing the dead tree" or "The bear was bigger in real life," there's a good reason. The human brain scans a scene, focuses on what it finds interesting, and subconsciously disregards the rest. Depending upon your personal likes and dislikes, your brain enlarges or reduces objects and colors. Film, however, doesn't selectively abstract information, so you end up with everything that was in the viewfinder, not just what you thought you saw. Elements you didn't even notice may draw the attention off your subject.

Many years ago, I was thrilled to see my first grizzly bear in the wild. I was excited and went through an entire roll photographing this bear, but when the film was processed, the grizzly was only a "raisin" in the overall photograph. My emotional reaction to being anywhere near such an animal had caused my mind's eye to enlarge the experience, which in turn enlarged the bear. Unfortunately, the film captured the reality of the experience.

My grizzly bear experience provided me with one of my first major lessons in composition: Make the

ICEBERGS, TRACY ARM, ALASKA. Canon EOS-1n, 28–135mm IS lens, Fujichrome Provia 100F. *In the bottom photo, the iceberg is the main subject, but a sense of scale is lost in the balanced proportion. In the top photo, I composed tightly so the iceberg looms in the frame.*

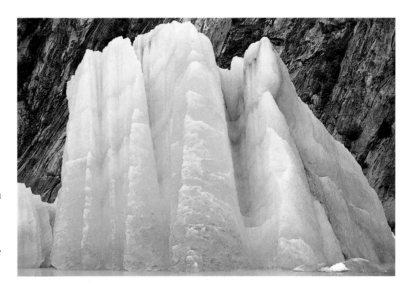

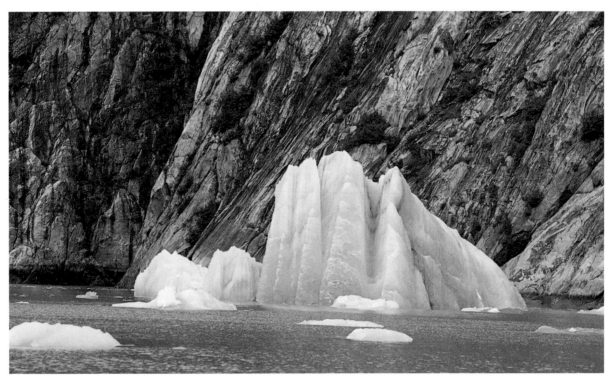

subject dominant. There are many ways to do so.

- Move closer or use a telephoto lens to increase the size of the subject and let it fill the frame. A frame-filling portrait of a bear is powerful because we think of bears as large, strong creatures. When the bear becomes the dominant element, the photo suggests a thrilling face-to-face encounter.

- Select a camera position to isolate the subject from a messy or merging background. Photographing an object from overhead can eliminate an otherwise distracting background, while photographing from a low viewpoint can isolate the object against the sky or some other simple background.

- Use selective focus, with an aperture that minimizes depth of field, to make the subject stand out from the background.

- When photographing a landscape, place an interesting element in the foreground to create a strong point of dominance.

- Compose your scene so other elements support or draw attention to the main subject.

Once you've taken any of these steps, look at the scene one more time before pressing the shutter to make sure you've effectively made your subject dominant in your final composition.

As you work with composition, you'll probably be surprised to notice the many ways various elements affect dominance. For instance, a small object will appear dominant in a field of larger ones, and an object that breaks up a pattern will also become dominant. A single rock standing in a meadow of wildflowers will dominate the scene, no matter how many wildflowers there are. A dominant color can draw attention away from the main subject, and since the eye is drawn to the brightest areas of a scene, like a moth to a flame, an area of brightness will dominate any scene.

ANDEAN FLAMINGOS (controlled situation). Canon EOS-1n, 80–200mm lens, Fujichrome Provia 100F rated at ISO 200. *An out-of-focus flamingo in the background emphasizes the one in the foreground, giving dominance to the bird in the foreground.*

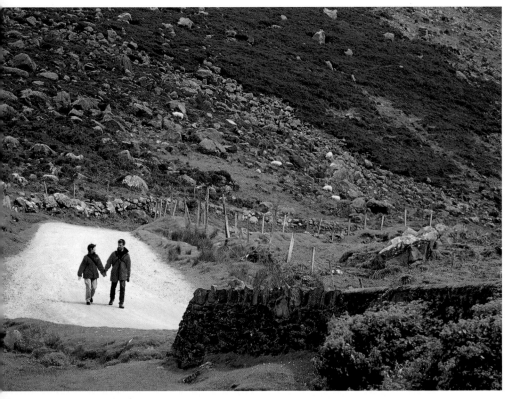

Left: HIKERS, COUNTY KERRY, IRELAND. Canon EOS-1n, hand-held, 75–300mm IS lens, Kodak E100VS. *Although they are small, this hiking couple dominates the scene because of their bright red jackets and because they are located in the brightest area of the frame, to which the eye is naturally drawn.*

Below: NILE RIVER, EGYPT. Canon EOS-1n, 300mm lens, Fujichrome Provia 100F. *This scene simultaneously emphasizes the smallness of the boat and the largeness of the sun. The two compete for attention, creating a nice diagonal line of movement across the metallic orange surface of the river. This also creates a feeling of depth to the scene.*

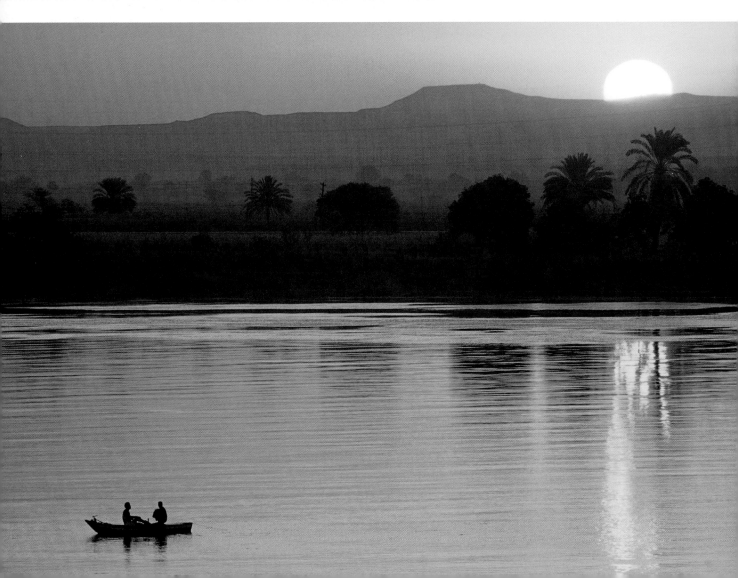

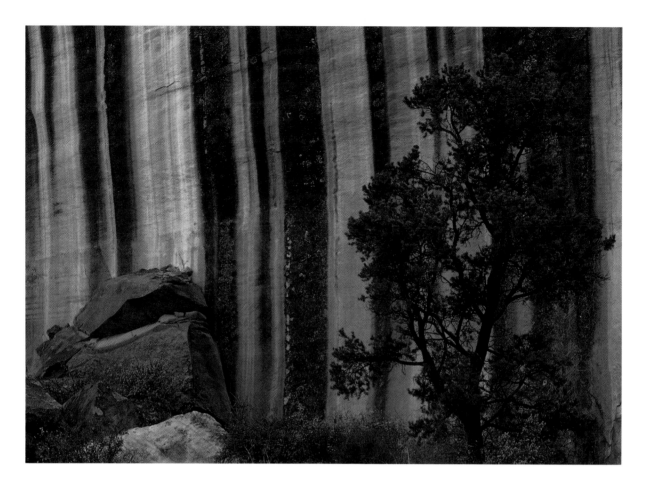

BALANCE

Balance is harmony, or a sense of equilibrium. If you thoughtfully arrange the elements in a scene—keeping in mind that every object or element in a photograph has a particular visual weight, which is decided by size, shape, location in the frame, color, and other properties—you can create a balanced photograph. But do you always want that? Would you really want an image of whitewater rafting to be perfectly balanced? Or would you prefer a little imbalance, some visual tension to convey the excitement of the moment? While the eye seeks harmony and equilibrium, providing the opposite is stimulating. The eye has nothing do when it scans an image that is balanced too perfectly, so interest in the photograph can quickly fade.

There are two types of balance: symmetrical and asymmetrical. With symmetrical balance, everything is oriented around the center of the picture. For example, a scene reflected in water, composed with the water's edge centered in the frame, is a symmetrical composition. In a picture that is too equally balanced, a visual stasis can occur, and the resulting photograph can lack impact and beg for an element that breaks up the monotonous order. I rarely create a totally symmetrical composition, unless perfect symmetry is the whole point of the photograph.

DESERT VARNISH, CAPITOL REEF NATIONAL PARK, UTAH. Canon EOS-1n, 80–200mm lens, Fujichrome Velvia. *The dramatic lines of desert varnish contrast with the organic shapes of the rocks and tree. Without the lines to tie them together visually, the rock and tree would be balanced too evenly in the frame, creating a visual stasis.*

On the other hand, asymmetrical balance provides the articulated energy that I want my photographs to possess. Compositions that are asymmetrically balanced have an informal feel to them and, as a result, are often more appealing to the eye. With asymmetrical balance, elements of different size or proportion are balanced off each other. To achieve artful asymmetry, you can balance a small object with a large one or a dark object with a lighter one or offset negative space with space that is visually "full."

Visual tension develops from the interaction of elements in a photograph. One object may be more dominant, but another object can command enough attention to force you to look at it. The resulting tension stimulates the eye, as it keeps moving between the objects in the image. For example, a red tulip

amid a field of yellow ones will create visual tension. The yellow tulips may dominate the composition, but the eye will also be drawn to the red tulip.

Left: INDIAN CANYON CREEK, YOSEMITE NATIONAL PARK. Canon EOS-1n, 80–200mm lens, Fujichrome Velvia. *By placing the rock at the bottom of the flowing water, I gave the eye a place to rest and prevented it from running out of the frame along with the water.*

Below: PEACOCK IN FULL DISPLAY. Canon EOS-1n, hand-held, 75–300mm IS lens, Kodak E100S. *I was drawn to photograph this beautiful peacock by its symmetry, along with the iridescence of its colors. Still, the image is not perfectly symmetrical, because I didn't want to lose the bird's form by photographing it straight on.*

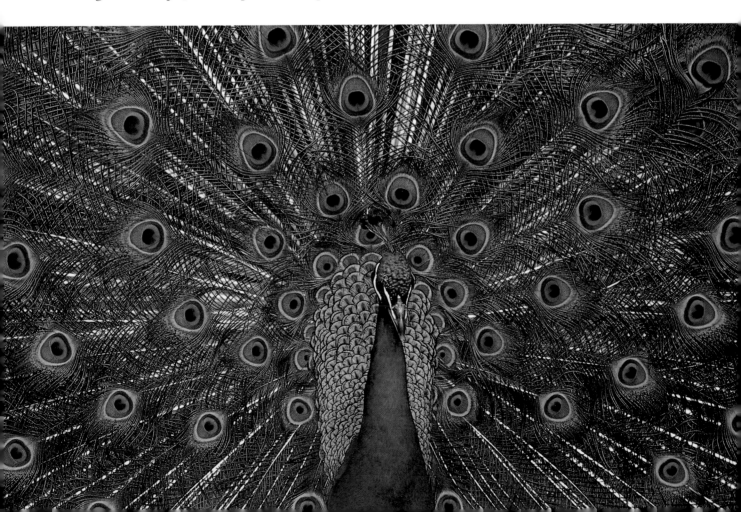

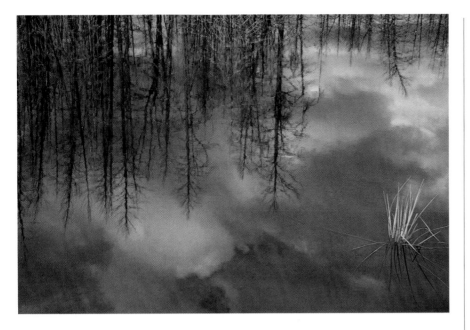

Left: STORMY REFLECTION, YELLOWSTONE NATIONAL PARK. WYOMING. Canon EOS-1n, 20–35mm lens, Fujichrome Velvia. *Something about the mood of the scene made me stop the car to check out this pond. That's when I found the tuft of fresh green grass and used it to offset the reflection of burned trees, creating a stormy, almost surreal image.*

Below: HAYDEN VALLEY, YELLOWSTONE NATIONAL PARK, WYOMING. Canon EOS-1n, 80–200mm lens, Fujichrome Velvia. *The soft shadows of the snowy hill balance the composition, even though the tree is positioned to the extreme left in the frame.*

The term "negative space" refers to an area within the frame that is empty of detail. Have you noticed how hard it is to keep that space from standing out too prominently and creating a feeling of imbalance? Too much dark space, such as a shadow without detail, can create a visual vacuum, drawing your eye away from the subject into the hole. You usually won't want to have too little negative space in a photograph, though, because the main subject can appear to be jammed into the frame. Just becoming aware of negative space in your composition will help you develop your own intuition about how much "feels" right.

PROPORTION

Proportion can help you express symbolism. A frame-filled photograph of pumpkins, squash, and gourds suggests the variety of the harvest. A photograph of the same subjects arranged so they stretch far into background suggests the abundance of the harvest. A sense of proportion derives from what you want to say about a scene. Is it the sky that's screaming for attention, or a cluster of giant columbine? Once you decide what you want to express, you can create a proportional relationship of elements to articulate your idea.

When I was kayaking on Frederick Sound in southeastern Alaska, I wanted to convey a feeling of wide-open space, so I asked my friends to paddle out in front of me. Using my 24mm lens, I placed their kayak at the bottom of the frame and exaggerated the proportion of the sky to emphasize my message.

An object doesn't have to be large to command attention. In fact, the smaller a subject is in relation to any surrounding objects and the more contrast it has to those objects, the more dominant the subject can become.

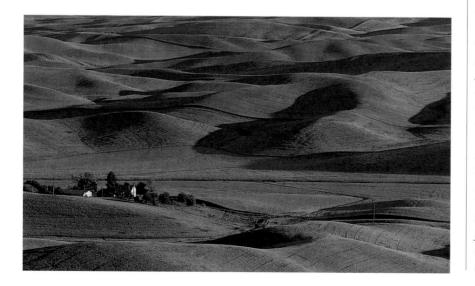

Above: WHITE HOUSE RUINS, CANYON DE CHELLEY NATIONAL PARK, ARIZONA. Canon EOS-1n, 300mm lens, Fujichrome Velvia. *To emphasize the fact that this ruin is nestled at the base of very steep cliffs, I framed it vertically and gave a larger proportion of the frame to the cliff surface. The sweeping lines of desert varnish help by drawing the viewer visually down the wall to the ruins.*

Left: FARM, EASTERN WASHINGTON. Canon EOS-1n, 300mm lens, Fujichrome Velvia. *Surrounded by seemingly endless green fields, this tiny farmhouse and barn stand out because of their brightness in relationship to their surroundings.*

Left: SUNRISE, ANZA BORREGO DESERT STATE PARK, CALIFORNIA. Canon EOS-1n, 20–35mm lens, Fujichrome Velvia. *Dawn turned the sky an incredible shade of red and orange on this morning. Since the sky was the main subject, I kept it large in the frame and anchored it with just a little bit of silhouetted mountains.*

Below: WOMEN IN A PARK, SAN FRANCISCO, CALIFORNIA. Canon EOS-1n, 28–70mm lens, Fujichrome 100. *I was photographing the tulip gardens when I saw these two women chatting. For a sense of place, I included the tulips in the foreground. Although the tulip bed is larger than the women, their light clothing draws the eye across the tulips, and the two spaces are tied together.*

I regularly use proportional balance in this way to establish relationships that express my ideas. I emphasize an object or element by making it larger proportionally in the frame, but I do so conscientiously and make sure that every element balances out proportionally.

EXPRESSING A SENSE OF SCALE

S cale is conveyed by the exaggerated proportional relationship of objects in the scene. While standing at the side of the road in Capitol Reef Park in Utah one afternoon, I marveled at the massive formations of red sandstone and realized how small I felt in that dramatic landscape. In front of me, the cars coming around the bend appeared to be as small as I felt, even though I knew that they were normal size. Realizing that I could show this sense of scale, I reached for my camera. Under normal circumstances, I might have selected my wide-angle lens to highlight the "small versus large" relationship, but in this instance I wanted to convey the feeling of the massive rocks that were pressing down on the cars. My telephoto lens allowed me to visually draw the cliffs closer, making them appear to loom over the car. This is a case of using proportion creatively to emphasize scale, an approach that can be very effective.

NATIONAL ELK REFUGE, JACKSON, WYOMING. Canon EOS-1n, 300mm lens with 1.4 teleconverter, Kodak E100S. *Tiny figures in a massive snowy space, these migrating elk move back and forth across the plains of the refuge. Proportion can provide a sense of scale, as this image shows.*

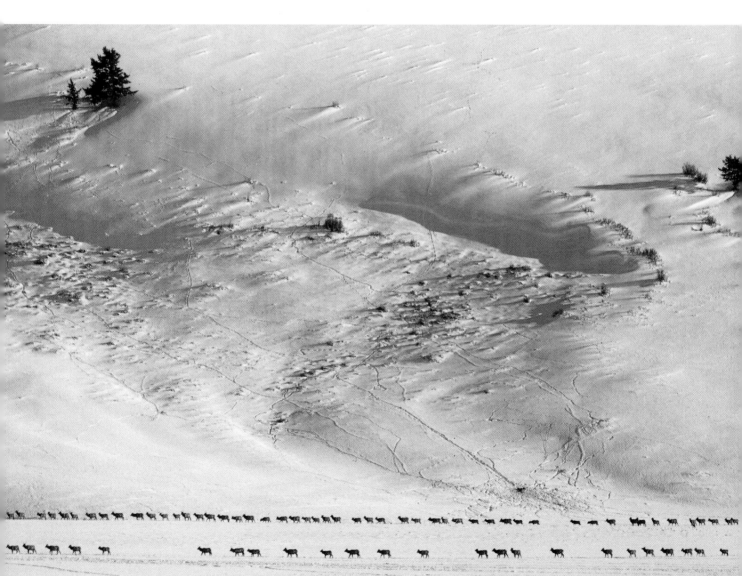

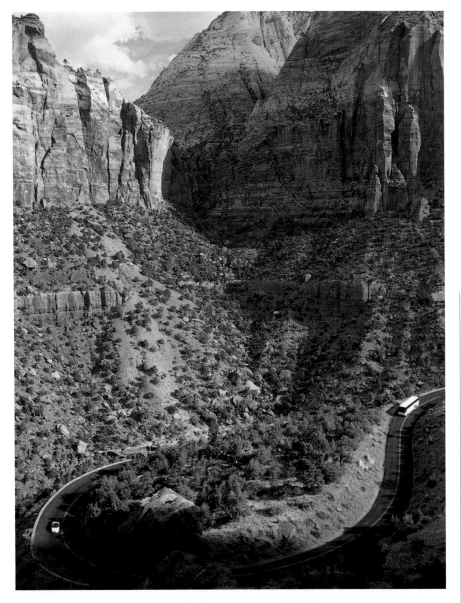

Above: CAPITOL REEF
NATIONAL PARK, UTAH.
Canon EOS-1n, 300mm lens,
Fujichrome Velvia. *To express
the height of the sandstone forma-
tions in the park, I composed this
scene with a long telephoto lens
that visually compressed the space
between the terraced cliffs and the
car on the road.*

Above left: ZION NATIONAL
PARK, UTAH. Canon EOS A2,
28–70mm lens, Fujichrome
Velvia. *The steep sandstone walls
of Zion are its trademark, and
I wanted to make an image that
captured their height. Standing
near the top of the switchbacks,
I photographed a bus as it wound
down the S-curve of the road
below. Vertical framing adds to
the feeling of height.*

Below left: BERNESE OBER-
LAND, SWITZERLAND. Canon
EOS A2, 28–70mm lens,
Fujichrome Velvia. *To show
the size of the mountains that
surround a hiker in the Swiss
Alps, I kept the people very small
in the photograph but used a
relatively normal focal length.*

LESS IS MORE

Unlike painters who begin with a blank canvas, photographers start with a full scene and have to eliminate the things they don't want in the picture. The goal is to simplify. When you include too many ideas or elements in a composition, you can end up with a disorganized collection of subjects and your main subject becomes lost in the chaos. Frequently, the real picture is within the picture that you made. Your viewfinder contains a highly competitive world of objects, and you must get rid of all that are nonessential or distracting. Repeat after me, "Simplify, simplify, simplify!"

If you doubt the wisdom of this imperative, take another look at your photographs and see how many could

have been improved by simplifying the composition. When you make a print, how often do you crop the

MARSHALL POINT, PORT CLYDE, MAINE. *Top:* Canon EOS 3, 28–135mm IS lens, set at 28mm, Fujichrome Velvia. *Bottom:* Canon EOS 3, 80–200mm lens, set at atound 180mm, Fujichrome Velvia. *The light on this autumn afternoon was incredibly clear and warm in hue. The house stood in contrast against the cobalt blue sky, and the light and shadow play on the porch steps was exciting. I kept working the scene, going in tighter, emphasizing the lines and the graphic pattern they made. The image below simplifies the scene and still combines great light, color, lines, patterns, and shapes.*

image? Learn to crop in the camera first. Your challenge in making a strong photograph is to reduce the visual clutter, to get rid of everything extraneous. You want to have one main subject or idea in your composition, and you need to eliminate anything that does not support that idea. Nothing in an image is neutral.

Use your feet to reduce or eliminate areas of clutter in your picture. Yes, your feet—use them to move closer to your subject. As you move in, your subject becomes larger, which increases its dominance. Extraneous elements fall away outside the viewfinder. It's amazing how much this simple exercise will improve a photograph. If you can't get closer to the subject, use a telephoto lens to eliminate background clutter.

You also need to keep an eye out for lines that may be leading the eye away from the main subject to other elements in the photograph or to the edge of the frame. Color, too, can draw the eye away from your main subject.

◈

As you integrate the ideas of dominance, balance, and proportion into your own photography, an intuitive sense of composition will develop, freeing you to concentrate on other aspects of the photograph. The goal is to make a photograph as expressive as possible, short of having motion or gesture in it. Between visual design, perspective, and composition, you now have many tools at hand to help you do that.

ANTELOPE CANYON, ARIZONA. *Above left:* Canon EOS-1n, 28–70mm lens, set at around 50mm, Fujichrome Velvia. *Above right:* Canon EOS-1n, 80–200mm lens, set at 200mm, Fujichrome Velvia. *Great light was bouncing into the canyon, defining this wonderful shape. I used a short telephoto lens to make the photograph on the left, illustrating the clutter. Then I moved and changed lenses, simplifying the composition and reducing the extreme range of light.*

THE IMPORTANCE OF THE FRAME

The next time you get film back from the lab, examine the ratio of vertical images to horizontal ones. You'll probably discover that most are horizontals. I make many vertical images, yet even I am surprised by the percentage of horizontal images that I create versus vertical ones.

Does this matter? Only if an image would be stronger if you were to compose it vertically rather than horizontally. As a general guideline, horizontal framing accentuates the width of an object, and vertical framing shows the height of an object. Framing can have an emotional impact on the image, as

well. Sitting empty on a page, a horizontal rectangle is more peaceful, because the longer two lines dominate the space and suggest a feeling of calm. A vertical rectangle expresses more vitality, as the longer two lines are upright and suggest strength. If you frame a tree or other strong vertical subject horizontally, you can create a cramped feeling in the frame unless you shoot from a distance to show space around the tree, but then the tree may no longer be the dominant subject in the frame.

I am not suggesting that vertical subjects should only be framed

GOLDEN GATE BRIDGE, SAN FRANCISCO. Canon EOS-1n, 80–200mm lens, Fujichrome Velvia. *I was able to make two nice images of the bridge on a clear afternoon just by changing my framing. In the photograph on the facing page, I had to make sure that the foreground cliffs would not dominate the lower part of the frame. So I tilted the camera up just slightly, keeping the tower parallel to the edge of the frame. The proportions of the bottom photo remain very close to those of the first, yet this image provides a wider view of the bridge and the city behind it.*

vertically, or that horizontal subjects should be framed horizontally. You can often create great compositions by photographing the same subject both horizontally and vertically. You may not even have to change position or focal lengths.

It's always worth considering the alternatives of vertical versus horizontal compositions to create a dynamic photograph. Because I sell my photographs, having both horizontal and vertical photographs is essential. Magazine covers require vertical images, whereas a billboard image is usually horizontal. When I find a good location with great light, I challenge myself to find ways to create exciting photographs with both orientations. I am forced to use design, perspective, and composition techniques to make both images visually arresting, which in my case translates to their being more potentially saleable.

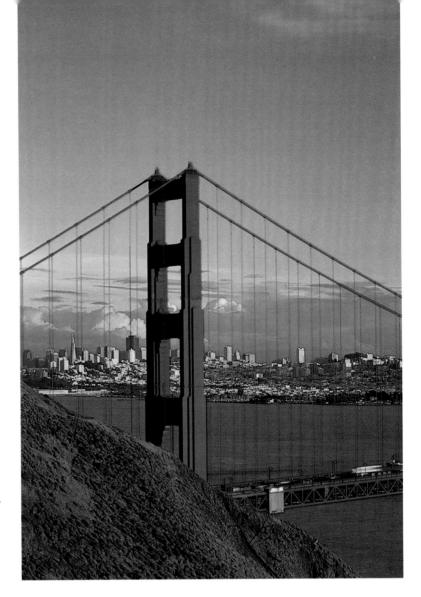

COMPOSITION CHECKLIST

Walk around with your camera first to find your photograph. Don't settle for "second choice." The first place you stop is usually not the best.

Think about what you're trying to highlight and find the best angle of view and viewpoint you can to make that statement.

Be willing to bend and stretch for your point of view. Don't be lazy!

Simplify.

Check for background distractions through the viewfinder.

Preview the depth of field.

Perimeter check—watch the edges of the frame for any extraneous "stuff." Your camera may show you less than what you get on the film. Learn how much by testing, to help eliminate surprises later.

Check for overlapping tones that may not separate enough in the final frame.

Watch for bright areas such as sky, sunlit patches, reflections. They can ruin your day!

Watch for "the hand of man" in your nature landscapes—telephone poles, road signs, contrails.

Watch for small distractions in macro compositions—cobwebs, moving bugs, pollen "dots" on petals, leaves.

WORKING THE SITUATION

Too often, photographers don't get the most they can out of scenes. As an exercise, the next time you're in a well-known location, challenge yourself to see what's around you differently. Make the "predictable image" first, if you must, but once you're past that, get into the scene. Zoom with your feet, not just your lenses. Try different focal lengths and different points of view. Return at a different time of day or night. If the light is great and the location is great, you have the main ingredients for dynamite photographs. Also, explore the surrounding area and see what else there is to shoot. I've been to Zion National Park many times, and ironically I still do not have a photo of Checkerboard Mesa! Although it's a visual magnet for photographers, I've spent most of my time photographing in the washes and up the side canyons.

When I'm on assignment, I need to take advantage of a great opportunity and make as many good compositions as I can, until the light—or my film supply—runs out. That doesn't mean that I run around frantically. Well, okay, sometimes I do get a bit frantic, but I still work a composition to make the best image I can before I move to the next point of view. When I was first starting out in photography, I had a difficult time justifying the money I spent on film and processing, so I'd use my film sparingly. It never occurred to me that the time and money I spent getting to a location cost more than the film itself.

YOSEMITE FALLS, YOSEMITE NATIONAL PARK, CALIFORNIA. Both Canon A2, 80–200mm lens, Fujichrome Velvia. *To really work a location, you must visit it under all conditions of light. I waited until the sunlight struck the falls completely, and although I lost the warm light of morning by 9:30 A.M., I made a pleasing image of the falls in spring (below). Curious about what the falls would look like under full moonlight, I went back that evening and made another photograph, complete with a few star trails (facing page).*

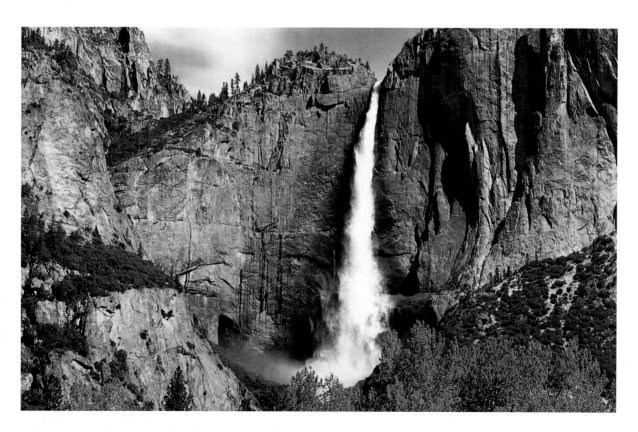

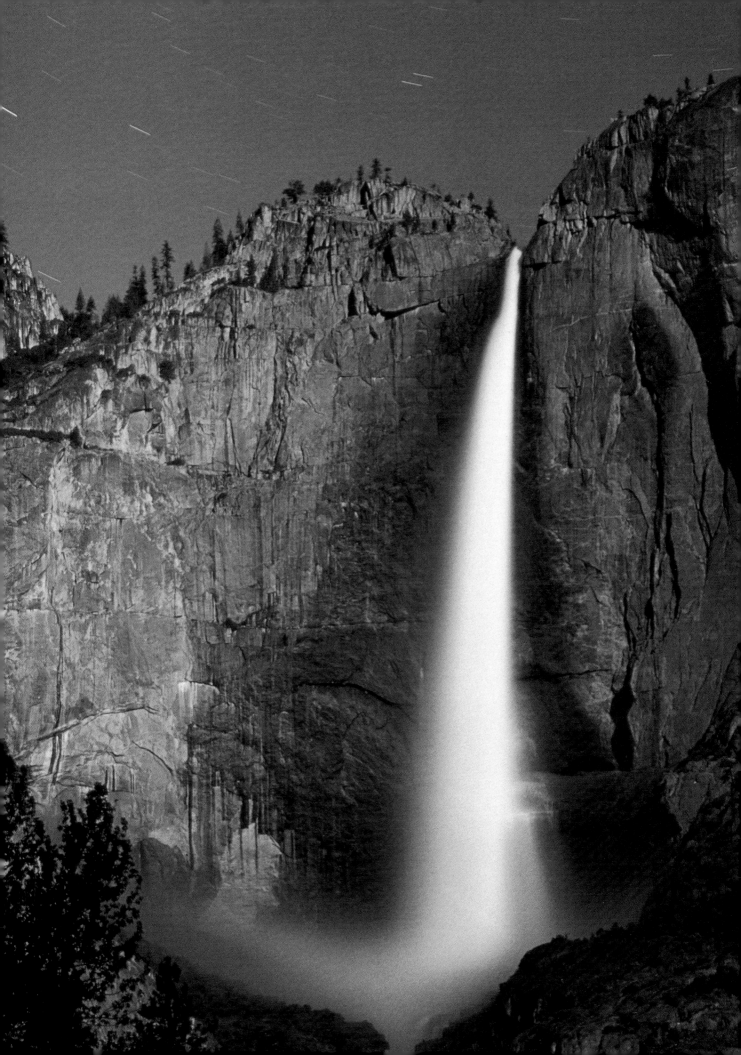

CREATING RHYTHM

I f you listen long enough to some-
one who taps out a rhythm, you'll
be able to pick up the rhythm and
tap along in time, even if you don't
know the melody. You probably
won't pick up the rhythm with just
two or three taps, because rhythm is
established over time.

The same thing happens with
rhythm in photography. You can
establish a rhythmic feeling with
just three or four similar objects
repeating in your frame, but the
rhythm will be stronger if you have
more; you need to provide enough
beats or repetitions of elements and
enough space for the rhythm to
become established. While visual
rhythm is often equated with wavy
or curving lines, a row of repeating
rooftops can be rhythmic if the
repetitions create a measured move-
ment for the eye to follow. If you
compose so that the elements extend
beyond the edge of the frame, you
strengthen the effect of rhythm, as
the mind assumes that the repetition

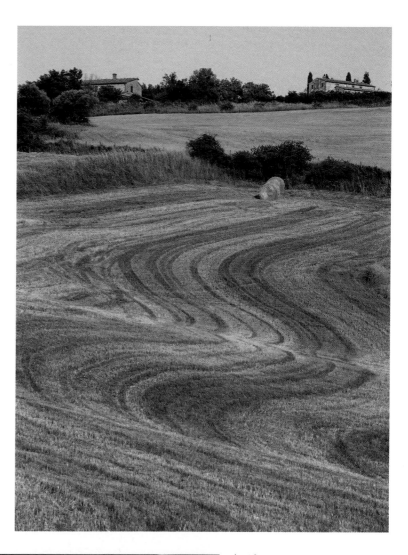

Above: HARVESTED FIELD,
TUSCANY, ITALY. Canon EOS 3,
300mm lens, Fujichrome
Velvia. *The repetitive S-curves
made by the harvester in this
wheat field create a rhythmic
movement that slowly draws the
eye from foreground to back-
ground.*

Left: KAYAKS, MAINE.
Canon EOS-1n, 80–200mm
lens, Kodak E100S. *While
shopping for outdoor supplies, I
spotted these stacked kayaks. The
curving diagonal lines created
a rhythmic image of a pile of
plastic boats.*

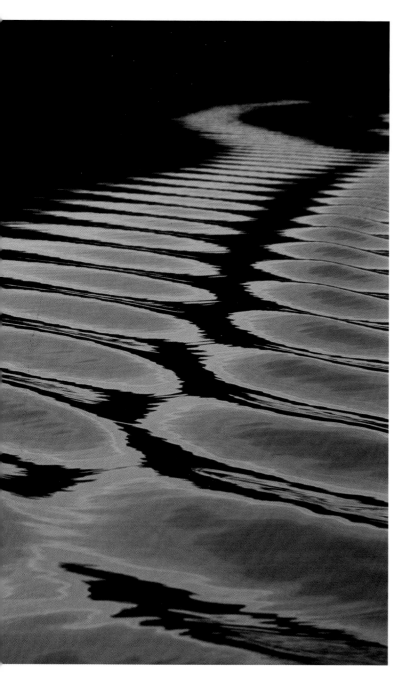

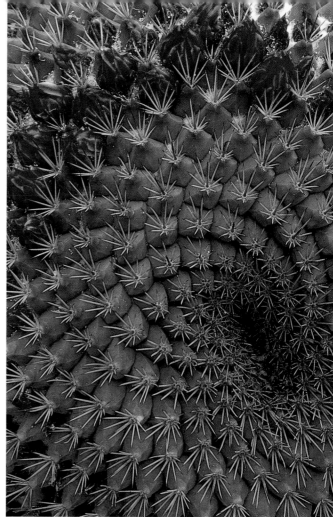

Above: CACTUS, ARIZONA. Canon EOS-1n, 90mm tilt-shift lens, Fujichrome Velvia. *I loved the spiraling effect of this cactus. To make the eye travel around the spiral, I composed tightly, including the buds for a little color break. The repetitive movement inward creates the rhythm.*

Left: BOAT WAKE, ALASKA. Canon EOS 3, hand-held, 28–135mm IS lens, Fujichrome 100. *One cloud produced all this wonderful color at sunset. To make this image of rhythmic pattern, I stood on a cooler to get a higher point of view, showing the pattern receding into the darkness.*

continues. While photographing near Stanley, Idaho, I found a wonderful split-rail fence that zigzagged through a huge meadow. In the near distance, two cows lay ruminating. When I chose a point of view that used the fence to draw the viewer back to the cows, I created a rhythmic way to move the eye through the scene. It was a much nicer way to get there than just using a straight line!

You can use any focal length to create rhythm. A wide-angle lens provides you with lots of space to develop it; a telephoto lens gives you less space, but you can stack objects tightly to establish rhythm more quickly. Creating rhythm requires you to consider all the other factors of composition, perspective, and design. It can be the final crescendo in a well-designed and composed photograph.

WORKING WITH
COLOR

Color is a language by itself. —ERNST HAAS

Color touches us on a deep level and evokes an emotional response. As a result, color has the power to create mood in a photograph. Pictures made in the blueness of twilight convey a mood of tranquillity and calm. Photographs of bright yellow objects convey a mood of cheerfulness, or aggression. Why is a sunflower cheerful? The color brings out the cheerful emotion.

Each color has its own attributes and visual weight. Warm colors tend to advance and cool colors to recede. Reds feel heavy, blues feel light. Think of how we respond to colors in nature. The earthy brown, beige, and ochre hues of a meadow in autumn represent a return to the earth. In spring, in the very same meadow, the lime-green hues of new shoots and leaves represent rebirth and growth.

You can employ these attributes to give power to your photographs. While you don't always get the opportunity to choose the colors you are working with, to a certain degree you can manage them. Color is an element of a creative photograph, just like line or shape. You can emphasize or de-emphasize colors by your choice of viewpoint, focal length, and composition. You can visually arrange colors in your frame to create harmony or tension. You can use contrasting colors to accentuate your subject, or make color the main subject of your photograph. If you develop an awareness of the properties of color and how colors relate to one another, you can make better color photographs, no matter what your subject matter is.

HOT AIR BALLOON Canon A2, 80–200 lens, Kodachrome 64.

THE PROPERTIES OF COLOR

The gestalt of colors comes from our experiences with these colors—for example, our experiences with fire, sun, sky, water, and snow. These experiences define how we respond to color, regardless of subject matter.

Yellow, the brightest of all colors, radiates light in a photograph. It advances visually when set against any other color except white. Yellow is emotionally aggressive and vigorous, radiates warmth, and represents strong light. Because it is so strong visually, yellow can dominate a composition, even if it appears in only a small portion of the frame. This is true even when yellow is darker in value than other colors.

Red is bold and energetic, and expresses energy, power, and vitality. Blood is red, and so are stop signs and danger signs. Bright or deep red flowers almost seem to pulse when they are in a bouquet. When set against cooler colors, such as green or blue, red advances visually and has a kinetic energy. Like yellow, red can dominate a photograph even if it takes up only a small proportion of the frame.

Blue is not as active as yellow or red and is often referred to as a quiet color. Blue implies coolness, sometimes even coldness. Blue can take on an ethereal quality. It expresses a meditative mood and can also evoke a feeling of loneliness. Blue can easily dominate other cool colors, but it stays in the background when yellow and red are around.

The *secondary colors* green, purple, and orange also have emotional attributes. Green expresses growth, hope, and youthfulness; purple expresses mystery and spirituality; and orange, like the yellow and red it's derived from, expresses heat and

Above: SUNFLOWER. Canon EOS A2, 100mm macro lens, Fujichrome Velvia. *The yellow sunflower petals dominate the scene, but the green sepals at the bottom edge counterbalance the large area of yellow. Since light colors tend to visually float in the frame, the sepals anchor the yellow petals.*

Left: STRAWBERRIES. Canon EOS A2, 100mm macro lens, Fujichrome Velvia. *The deep red of these berries expresses their lusciousness and shows the vibrancy of a pure red. Red suggests vitality, and these strawberries look good enough to eat!*

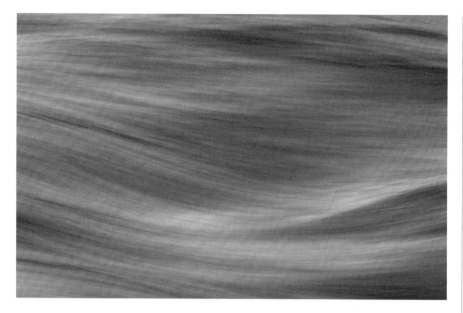

energy, as in fire. The yellow-orange light of sunrise evokes a feeling of warmth and energy, and an image of twilight evokes a feeling of peace and serenity. The lush green of a rain forest generates a feeling of growth.

Usually many colors exist simultaneously in a scene. Recognizing the visual weights of colors can help you select the proportion of each color element to use. For example, red is heavier

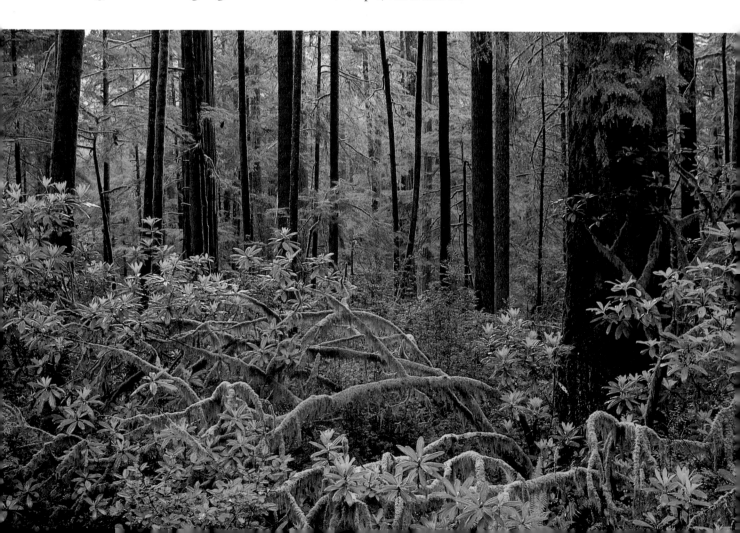

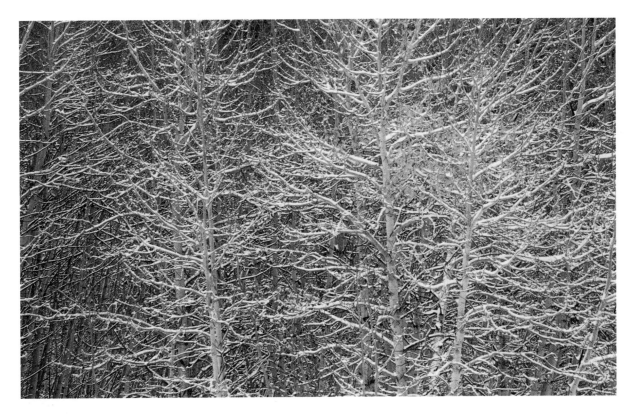

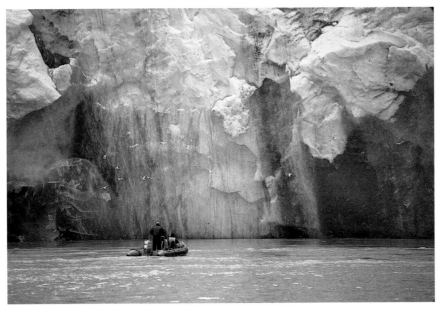

Top: CHAMA VALLEY, NEW MEXICO. Canon EOS-1n, 80–200mm lens, Fujichrome Velvia. *Yellow is such a strong color that you need very little of it to capture the eye's attention. The change from fall to winter was strongly evident in this image. The snow-covered trees help to keep the yellow leaves from being overpowering, but the eye is still drawn to them.*

Left: ZODIAC AND GLACIER, ALASKA. Canon EOS-1n, 300mm lens, Fujichrome Provia F100. *The proportions of the Zodiac and the face of the glacier suggest that the glacier is large, as the boat appears smaller in the overall scene. The boldness of the red pilot's jacket helps to keep the attention coming back to the Zodiac.*

than blue, so an image that has a lot of blue on the bottom and red on top may seem to be improperly weighted. Varying intensities of each color will produce different effects, too. For example, pink is a lighter, more delicate hue than a heavy red. Pink and red both express energy, but in different ways. Pink is a ballerina; red is a floor-pounding flamenco dancer.

Pastel colors present a gentle view of the world and create a soft mood.

The color palette you respond to is as unique as you are. Some photographers are drawn to bold, fluorescent colors, while others are attracted to softer hues. To find out what colors attract you, review a collection of images you have made and try to discern if you favor bold or pastel hues in your photographs.

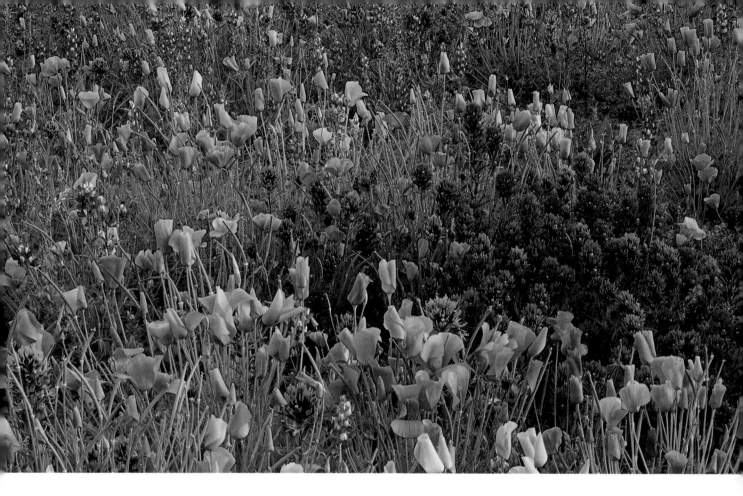

COLOR HARMONY

Have you ever noticed how pleasing red-orange sandstone is when photographed against a cobalt blue sky? Or how luminescent a yellow stamen is in a close-up of a purple flower? Color harmony is important in photography, even if we don't always get to choose the colors of our scene. For every color, there is an opposite color, and the two form a complementary pair. On the color wheel, orange sits opposite

Above: WILDFLOWER MEADOW, SOUTHERN ARIZONA. Canon EOS-1n, 80–200mm lens, Fujichrome Velvia. *When many of the colors of the spectrum are available in one scene, the image is pleasing to the eye. Mother Nature must have known this when choosing what to plant where.*

Left: SPIDERWORT BLOSSOM, CALIFORNIA. Canon EOS-1n, 100mm lens, Kodak E100. *The bright yellow of the pistol and stamen are offset by the deep purple hues of the petals, creating a harmonious color combination.*

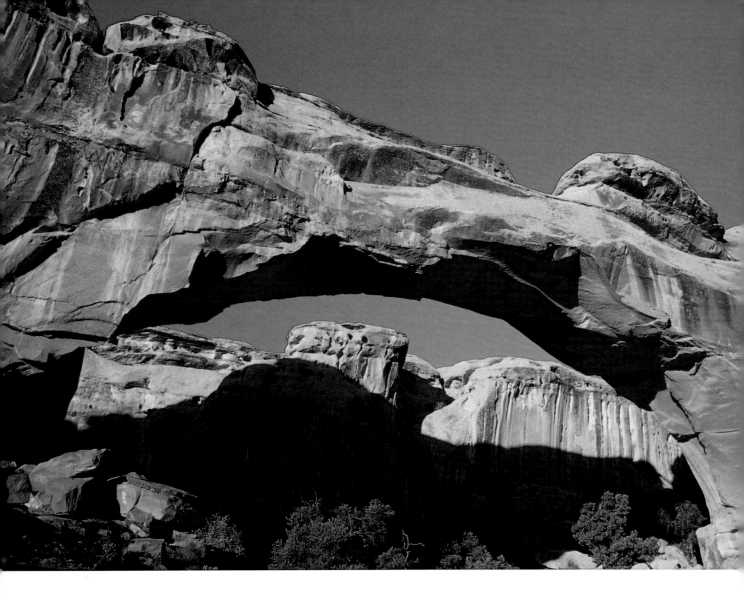

blue, violet sits opposite yellow, and green sits opposite red.

Ironically, in this colorful world, the eye and brain find balance in mid-gray. Complementary pairs of colors combine to make gray, so the eye needs both colors. Try staring at a red apple for about 20 seconds, then at a white piece of paper—you'll see a green apple, because the eye automatically supplies red to restore balance. Of course, photographs that contain only reds, oranges, and yellows can be wonderfully energizing, and photographs that contain blues, purples, and greens can be soothing to the eye and uplifting to the soul. The contrast of cool and warm colors in a picture, however, creates the balance the eye seeks.

Above: HICKMAN BRIDGE, CAPITOL REEF NATIONAL PARK, UTAH. Canon EOS-1n, 20–35mm lens, Fujichrome Velvia. *Rich orange hues of sandstone in morning light set against a cobalt blue sky provide a perfect example of nature's color harmony.*

Left: FIR BOUGH AND TUNDRA PLANTS, DENALI NATIONAL PARK, ALASKA. Canon EOS-1n, 28–135mm IS lens, Fujichrome Velvia. *Nature is at it again with complementary colors—green set against vibrant red.*

I use these color fundamentals in my photography, and I watch the way colors affect my images carefully. If there's a red or yellow object in the scene that isn't part of my subject, I position it carefully in the composition and control its proportion so it won't dominate the frame. However, if I need to add scale to my scene, I usually choose a red or yellow object that will draw attention to itself. I love to photograph scenes in which complementary colors are present, but I've also learned to work with the colors that are present in any situation.

Try this exercise. Pick a color, then spend a day photographing this color everywhere you encounter it. Look for the complementary color, too, so if you pick red, look for green as well. As you make your photographs, experiment with the concepts of dominance, balance, and proportion to see how the color you've chosen affects an image.

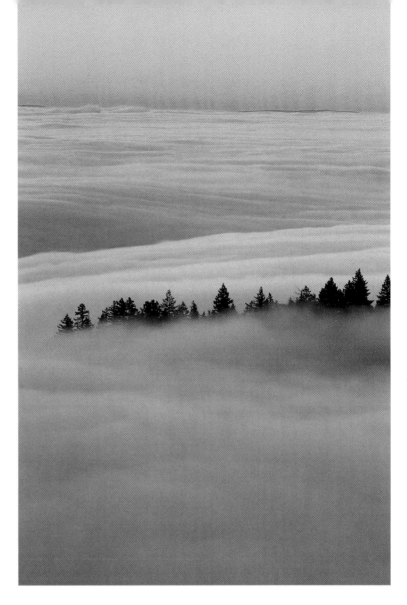

Above: TWILIGHT AND FOG OVER REDWOODS, NORTHERN CALIFORNIA. Canon EOS-1n, 300mm lens, Fujichrome Velvia. *The soft pink of the sky contrasts with the cool blue of the fog, and the combination is pleasing to the eye.*

Left: TRINIDAD BEACH AT SUNSET, CALIFORNIA. Canon EOS-1n, 28–135mm IS lens, Fujichrome Velvia. *A huge storm cloud overhead bounced light from the setting sun to the ocean's surface, turning the surface a rich magenta where the light reflected and a deep blue where it didn't. The cool-warm contrast, combined with the warmth of the setting sun, created a vibrant scene out of the simple elements of beach, water, and sky.*

EXPRESSIVE
TECHNIQ

Inside movement there is one moment in which the elements are in balance. Photography must seize the importance of this moment and hold immobile the equilibrium of it. —HENRI CARTIER-BRESSON

Photographs have the incredible power to convey the mood of a situation, whether it's joy, horror, tranquillity, or festivity. Good photography can reveal the movement and moments in both the natural and the manmade world. When we look at good sports photography, we feel the moments of triumph and despair; when we see fascinating moments in nature photography, we respond with awe and wonder. "We photograph to make a moment stay," says Sam Abell, a photographer for *National Geographic*.

Photographing moving things has fascinated me for many years and lets me express the energy of a world in constant motion. I've challenged myself to master the techniques that show motion, and I look for ways to use them at every opportunity. Once, when I was in Death Valley, cars were speeding by while I photographed mud patterns on the side of the road. I used a slow shutter speed to capture the cars whizzing past the beauty at my feet and to express what I felt they were missing.

Capturing motion, gesture, and mood are powerful ways to make your images resonate with energy and meaning.

WINDSURFING ON THE COLUMBIA RIVER, OREGON. EOS-1n, 500mm lens, Fujichrome Velvia. *To suggest the speed of this windsurfer, I panned on him using a 1/15-second shutter speed. I did several dry runs to get the timing down, and I was able to follow him when he turned sharply, sending up a spray of water. The board's sail and the surfer's body create a great diagonal, adding to the dynamic movement.*

UES

CELEBRATING MOMENTS

A whale breaching, a bird taking flight, a child laughing—all express a unique moment in time. For an outdoor and nature photographer, candid moments are the icing on the cake. For all the research and planning that might go into a trip to photograph the orangutans of Borneo, you can't predict what the animals will do once you're there.

Since candid moments are so unpredictable, it might seem impossible to apply ideas of visual design or good composition to them. Just getting the moment on film is often thrilling enough for some photographers. But a great moment in nature doesn't guarantee a great photograph.

Getting the moment on film is a combination of technical and artistic skills. If you hone your reflexes, you're going to be able to move quickly and capture a fleeting moment; likewise, if you've developed your artistic vision, you stand a much better chance of capturing a moment creatively. You have to be ready for a situation when, suddenly, right there in front of you, it happens. One morning in Arizona, my friend and I spotted a nest with eggs in a small cave in the canyon wall. We set up to photograph the nest, but when my friend's remote release got stuck in the "on" position, the sound of the motor-drive ricocheted

SAWYER GLACIER CALVING, ALASKA. Canon EOS-1n, 300mm lens, Fujichrome Provia 100F. *Moments in nature can be awe-inspiring demonstrations of powerful forces at work. I was fortunate to witness a large calving and captured the moment as large chunks of ice hit the ocean.*

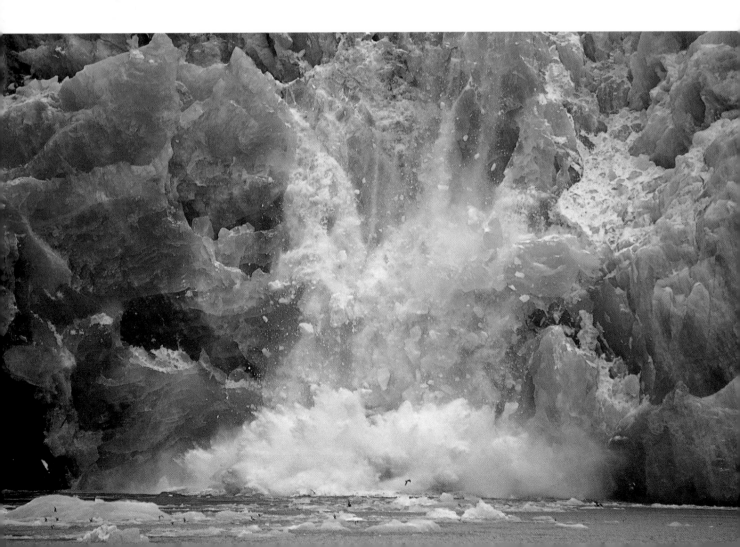

off the walls. In a flurry of feathers, a great-horned owl appeared in the opening, staring back at us. It all happened in a split second, but I managed to capture the moment of surprise before the owl flew out of the nest.

The key is to hone your timing. Parks are great places to practice. A golden retriever will fetch until it drops, so you'll have plenty of chances to get your timing down if you find a dog playing Frisbee with its owner.

Above: MAKING FRIENDS. Canon EOS-1n, 80–200mm lens, Fujichrome100, with fill-flash set at –1⅓. *This girl was fascinated with the horned lizard. When she reached out to touch it, I captured a moment of connection between the two. To suggest the girl was alone with the lizard, I framed the composition tightly to crop out other elements—except for her trusty Dalmatian!*

Left: BLACK-NECKED STILT FEEDING, BAYLANDS, CALIFORNIA. Canon EOS-1n, 500mm lens, Kodak E100VS. *The slender beak of this bird gently broke the surface tension of the pond. The ripples express the moment of contact and give the picture more energy.*

THE PUMPKIN PATCH

I had been driving past this pumpkin stand for about a week but was always too busy to stop. Finally I had the time to check it out. The shapes and patterns of the patch had attracted me from the road, and I thought I'd do a few photographs and buy a pumpkin for my porch. As I walked around, I noticed the place was buzzing with activity. Families were searching for the perfect choice, and children romped through the patch as if they had grown up on the farm. Fascinated by all the activity, I started to photograph what I saw. The late-afternoon sun struck a low angle across the whole scene, golden and crisp like the cool air. I studied children and families, and worked that patch until the last rays of light went over the ridge. I was there for only an hour, but I contentedly packed away four rolls of exposed film into the bag as I left. I was so delighted by the experience that I forgot to buy a pumpkin.

CAPTURING GESTURE

Gesture often defines the moment in many photographs, because we instantly understand what many gestures mean when we see them. A smile almost universally signals happiness or friendliness; hands folded in prayer generally represent a connection with the Creator in any religion; hands held high at the end of a race signify empowerment, a "Yes!" gesture. We can sense the mood of the moment in the way a person stands, sits, and walks. We understand the gestures of many animals, too—stretching, yawning, play-fighting, stalking. Consider, too, some of nature's more dramatic gestures—lightning bolts, volcanoes, calving icebergs, and rainbows. Even inanimate objects gesture.

These poignant moments bring life to a photograph and make your images resonate with visual energy. To increase your ability to capture a gesture, you must develop your skills of observation. The more you observe, the better you'll be at anticipating a moment of gesture. Practice taking photographs in places where moments are common, such as a wildlife refuge, a zoo, or a park. When a colleague of mine was starting out and didn't have money for film, he still practiced capturing moments every day— photographing dogs running in the park, or children playing, but without film in the camera. He couldn't see his results, but he could feel his compositions getting better and his anticipation skills becoming sharper. That's what I call dedication to the craft!

To become more prepared, develop an awareness of the moments or actions that can occur in certain situations. If you spend time observing huge flocks of snow geese, you'll learn that they often take flight en masse if a hawk or even an airplane overhead startles them. Rafters and kayakers tend to take the same path down a river,

CONDUCTOR, COLORADO. Canon A2, 28–70mm lens, Fujichrome 100. *The rich colors of the train car were a perfect background for a candid portrait of this conductor. He performed the classic gesture of checking his pocketwatch before calling out, "All aboard!"*

usually the safest one. Hikers move along a trail in similar fashion, since the trail directs the movement. You can anticipate certain moments at a farmer's market. People pick up produce, weigh it, exchange money.

Prepared with the knowledge of what can happen, you can go into a situation and be ready to seize the moment. When photographing in the outdoor market in Tlacoluca, Mexico, I knew what to expect since I had been to such markets near my home. Visiting a local park and photographing running dogs prepared me to capture a deer running across a meadow. However, when I first went to Alaska, I had had no experience with whales and was failing miserably at capturing the peak moment when the huge animals surfaced to feed. I couldn't tell where this was going to happen, so I was always in the wrong place at the right time. But a helpful naturalist taught me how to tell where the whales were about to surface, so I got my photos.

Many photographers talk about having a sixth sense when it comes to capturing moments on film, and I

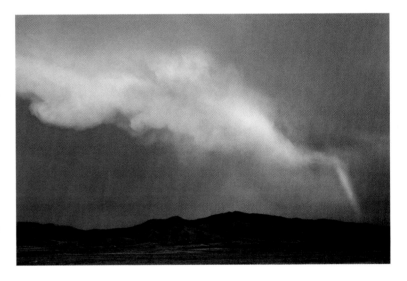

believe it's true. If your observation skills are strong, and you are attuned to what's taking place around you, somehow you just sense the moment before it happens. This isn't always the case, but it often is, perhaps because of our unconscious familiarity with the situation. I'd love to say that I always sense the moment and get it creatively onto the film, but I don't. It's a lifelong goal, so every trip into the refuge, the village, or the festival is an opportunity for me to try for those moments when light, design, and gesture all come together.

Top: WOLF KISS, GRIZZLY DISCOVERY CENTER, MONTANA. Canon EOS-1n, 300mm lens, with 1.4 teleconverter, Kodak E100S. *Wolves are very social, so I anticipated some kind of interaction when these two woke from their naps.*

Above: SUMMER STORM, NEVADA. Canon EOS-1n, 28–135mm IS lens, Fujichrome Velvia. *The expressiveness of the rain cloud and the contrasting rainbow are nature's own gestures. I chose to make the proportion of land small, to keep the attention focused on the cloud and rainbow.*

Left: SHEEP ROUNDUP, NEW MEXICO. Canon EOS-1n, 300mm lens with 1.4 teleconverter, Fujichrome Velvia. *I had followed this flock of sheep being herded down from higher pastures all day, in cold wind and snow flurries. As the drive was nearing its end, the flock emerged onto the main highway and provided an image that captures the essence of place.*

Below: HAWAII VOLCANOES NATIONAL PARK, HAWAII. Canon EOS-1n, 80–200mm lens, Fujichrome 100. *The most powerful experience I've ever had is watching molten lava flow out of the Earth. At dusk, it glows as it flows to the sea, and I photographed an awesome moment of the Earth re-creating itself.*

EXPRESSING MOTION

In this constantly moving world, it only makes sense that we would try to show the motion that we see and experience all around us. Of course, a photograph can provide only an illusion of motion; nonetheless, an image can be quite effective in creating a sense of speed or portraying the fluidity of movement. In a photograph of a car driving along a dusty road, the trailing dust cloud tells us the car is moving. The split-second shutter speed that captures a bird in mid-flight and the long exposure that records water flowing through a forest both convey motion, but in very different ways. Both, however, capture the magic of motion.

To photograph motion, you can freeze it, let the action move through your still scene, or pan with the movement. Each situation calls for a different technique. First ask yourself what quality of motion you want to bring out, and use that answer to decide on the technique you'll use.

BREACHING HUMPBACK WHALE, ALASKA. Canon EOS-1n, 300mm lens, Fujichrome Provia 100F. *Knowing where a whale is going to surface is key to being ready for the moment. I learned to study the water for a change in the surface tension. When this humpback threw itself out of the water, I was ready with a fast shutter and the motor drive. The diagonal line of the whale's body accentuates the movement.*

FREEZE FRAME

Freezing the motion captures the peak of the action, a view we never experience with our own eyes. When you use a high shutter speed to freeze the action, you seize the moment and create visual tension. A hand reaches toward the volleyball but doesn't touch it; a bird plunges toward the water, but the image is captured before impact.

A shutter speed of anywhere from ½50 to ½000 can stop most fast action. You have to factor in the distance you are from your subject, the focal length you're using, and the direction your subject is moving in relation to the camera. The closer you are to your subject or the longer the lens, the faster the shutter speed will have to be to freeze the motion; in a narrow field of view, the time it takes for your subject to travel across the film is very short and the motion is amplified. If the path of movement is parallel to the film plane, you'll need a faster shutter speed than if the movement is perpendicular or diagonal to the film plane.

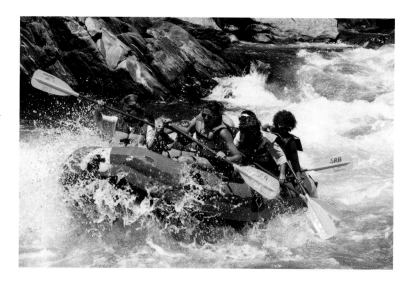

You can use existing charts as references when setting shutter speed, but the best way to develop a skill at freezing action is to get out there and practice with moving subjects. Remember the golden retriever playing in the park? He's still out there, only this time you can capture him in mid-air going for the Frisbee. Master your timing by photographing him, and you'll be ready when the cheetah pounces on its prey on the African savanna.

Above: RAFTING THE STANISLAUS RIVER, CALIFORNIA. Canon EOS-1n, 80–200mm lens, Fujichrome 100. *Using a ½00-second shutter speed, I froze the action of whitewater rafting, right down to the splashing water and frozen expressions of excitement. The picture suggests fast action and derives high energy from the diagonal position of the raft.*

Left: RAFTING THE SALMON RIVER, IDAHO. Canon EOS-1n, 80–200mm lens. *I slowed my shutter down to ½5 second and panned to capture this moment of action. In contrast to the stop-action image above, this one captures the frenzy of whitewater rafting as people paddle madly through the rapids.*

GOING WITH THE FLOW

Even with a still camera we can photograph the series of movements that constitute action. When I wanted to capture the tranquil mood of a forest in Yosemite and show a creek running through the scene, I set up the focus and aperture to create a sharp landscape. The 1-second shutter speed recorded the movement of the water, adding some life to the scene without taking away from the peace of the moment.

The shutter speeds necessary to capture different amounts of blurred movement vary widely and depend upon the speed your subject is moving. The faster the subject is moving, the faster the shutter speed will have to be. If you try to capture a dog running through your scene using a 2-second exposure, you may see nothing on the film! The slower the shutter speed and the faster the movement, the more transparent the object becomes.

If you want the background to remain sharp when you're using a slow shutter speed, you'll need to use a tripod. Other factors will also affect your results: the lens focal length, your distance from the subject, and its direction of movement. If the subject is moving toward or away from you, the shutter speed can be faster than if the subject is crossing the frame horizontally at the same speed. Charts can be very useful here, too, but it's also great fun to practice and learn through experience. When I get something

MERCED RIVER, CALIFORNIA. Canon EOS-1n, 80–200mm lens, Fujichrome Velvia. *Setting my camera for a 1-second exposure, I waited for the water to froth up. With the water flowing from left to right, I placed the breaking wave in the right third of the frame. The highly reflective water "painted" the colors of spring as it moved across the film.*

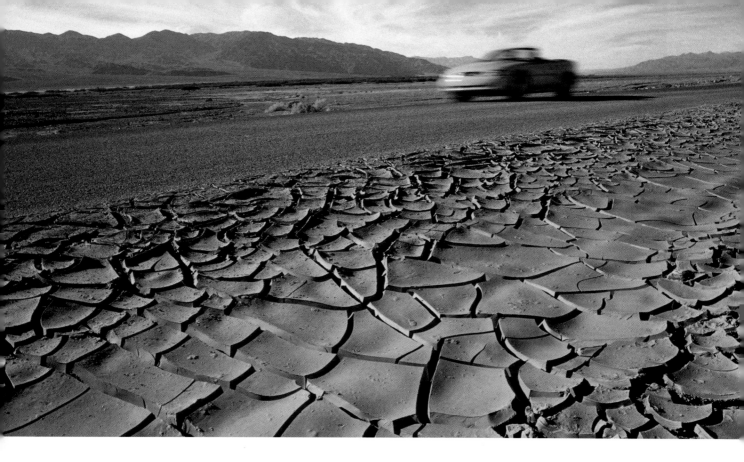

on film that works, the memory of how I did it always seems to stick.

I love to photograph moving water and prefer a soft "angel-hair" look to convey a fluidity and a soothing, ethereal quality. Water is a recurring theme in my work, but each water photograph I make is unique. When water moves through the frame, the light reflecting off it can "paint" across the film, creating an artistic interpretation. When you paint with light like this, you never really know how the image will look until you get the film back. If you vary your shutter speeds within a certain range, you'll be assured of getting something interesting from the exercise. I start with a shutter speed that I feel will work based on my experience. For swiftly moving water, I usually set the speed at between 1/8 second and 2 seconds. If you can get close to the water's edge and toss a stick into the flow, count the seconds it takes the stick to travel through your viewfinder.

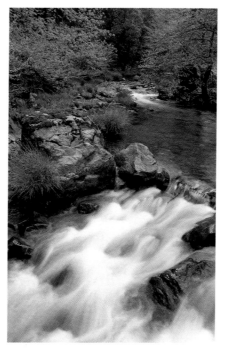

Then, using the tried-and-true method of "one Mississippi, two Mississippi" for counting seconds, set your shutter as close as you can to the number you come up with. The only way you can be certain of getting a good shot is to vary your speeds and experiment.

Above: DEATH VALLEY, CALIFORNIA. Canon EOS-1n, 20–35mm lens, Kodak E100S. *While I was busy photographing neat mud patterns along the side of the road, cars were whizzing by, no doubt wondering what the heck I was doing! Caught up in the humor of that thought, I decided to photograph it. I slowed to a ⅛-second exposure and waited for the right car to come by.*

Left: NORTH FORK OF CACHE CREEK, CALIFORNIA. Canon EOS 3, 20–35mm lens, Fujichrome Velvia. *I wanted to show the stream coursing its way through a quiet forest, so I chose a slow shutter speed (around ½ second) to capture the movement of the water. My wide-angle lens and the low position to the water emphasize the movement in the foreground, making the image more expressive, yet still tranquil.*

MOVIN' AND SHAKIN'

Panning combined with slow shutter speeds is another terrific way to express motion in a still photograph. I love this technique. Panning enhances the action and shows the "choreography" of the motion. You can feel the excitement and tension in a slow-shutter pan of white-water rafting. Elements overlap, and hard edges become smooth. Panning also cleans up messy backgrounds. At a rodeo I was photographing, the arena wall was covered with signs and the stands were filled with colorfully clothed people. By panning with a slow shutter, I blended all the colors sufficiently to eliminate the distracting signs. If the client had wanted a "freeze-frame" image of the action, my only option would have been to throw the wall out of focus as much as possible and hope the clutter would not interfere. Panning was far more interesting to me.

To get the full impact of the movement of your subject, choose a shutter speed that allows for enough blurring to show the movement yet retains enough detail to define the subject. This tip may sound vague, but there is no formula for panning

RUNNING DEER, NATIONAL BISON RANGE, MONTANA. Canon EOS-1n, 300mm lens, Kodak E100S. *Dusk provided the opportunity to try panning techniques on moving wildlife, since I couldn't get a fast enough shutter to freeze any action with the film I had in the camera. With an ⅛-second shutter speed and panning, I enhanced the movement of the deer.*

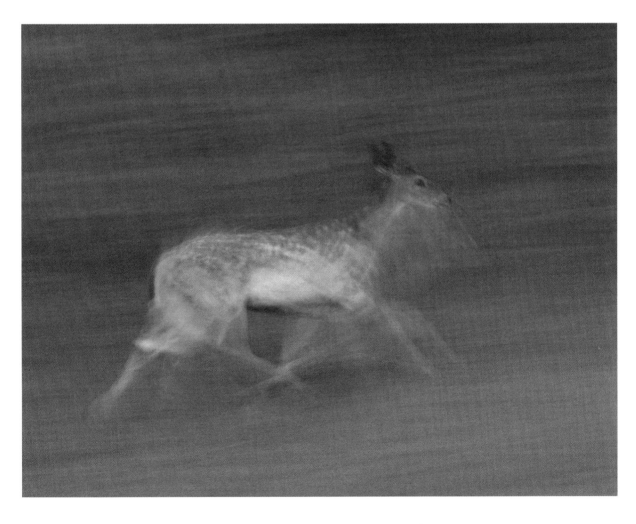

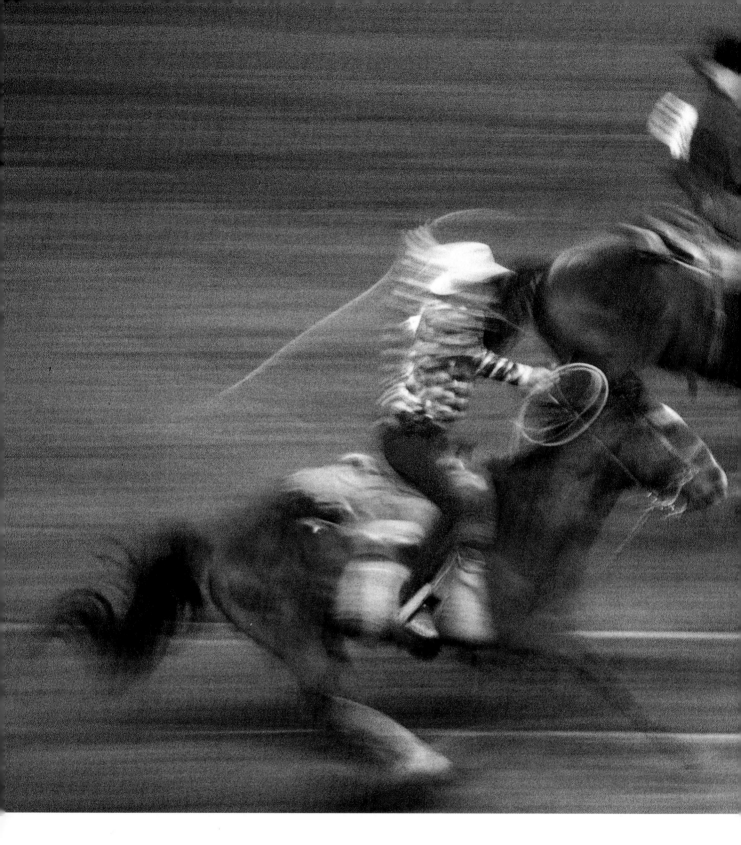

with slow shutter speeds. Situations vary greatly, and the surprise factor makes it fun and challenging to pan on moving subjects. Generally a faster shutter speed will record less movement and the background may be distinct. Again, the results will

be affected by the speed and direction the subject is traveling in relation to your viewfinder and the focal length you're using.

If you want smooth backgrounds streaked with bands of color, put your camera on a tripod; if you want

NATIONAL STOCK AND RODEO SHOW, COLORADO. Canon EOS-1n, 80–200mm, Kodak Tungsten 160, rated at ISO 320. *On assignment to cover the rodeo, I wanted to capture the choreography of the motion, so I set my shutter speed to ⅛ second*

an "organic," wavy background, hand-hold the camera. The only real way to develop a sense for what works is to experiment.

Finally, remember the importance of composition when photographing motion. If you don't put enough space in front of a moving object, the image will appear crowded and off-balance. Yes, you'll get plenty of "visual tension" if you position a dog as it is about to run into the edge of the frame, but that's probably too much tension to be pleasing.

and panned as this team chased down their calf. It took a few attempts to get the timing down, but the image captures the fluidity of movement, a sense of speed, and a moment of tension.

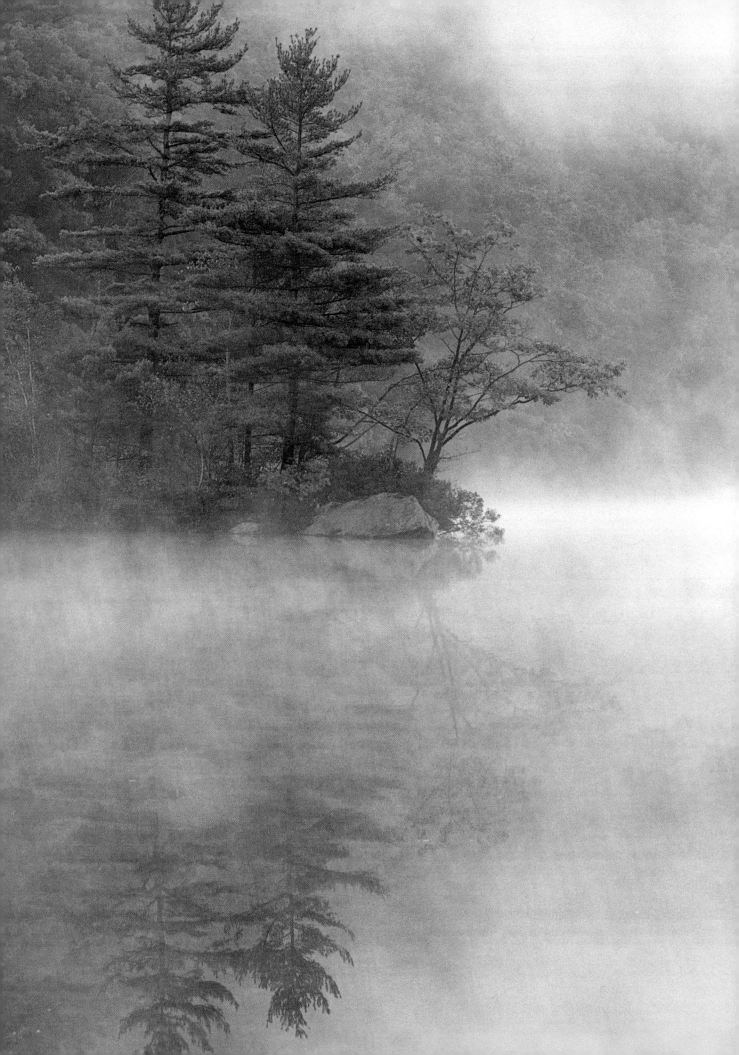

EXPRESSING THE MOOD

Mood is being in a particular state of mind or feeling. We capture this emotional quality on film by including the visual elements, gestures, or colors we associate with a particular mood.

Light imparts mood to a scene. Dark and stormy light expresses a threatening, foreboding mood. Foggy light can suggest either an eerie or a meditative mood. Bright sunlight expresses a cheerful, positive mood. Color also plays a big role in establishing a mood. The blue of twilight creates a mood of mystery, tranquillity, or aloneness. The red and orange hues of sunset create a warm, satisfying mood, one that suggests "the day is done, all ends well."

Gesture can also generate mood in a photograph. A person kneeling in prayer expresses a meditative

mood. A dog wagging its tail suggests an exuberant mood. My young nephew was playing in a kiddy pool

Facing page: LAKE MEGUNTICOOK, MAINE. Canon EOS-1n, 80–200mm lens, Kodak E100VS. *Backlit mist rising off a warm lake on a cool September morning created a meditative mood in this photograph.*

Left: CABIN IN WINTER, SIERRA NEVADA, CALIFORNIA. Canon EOS-1n, 80–200mm lens, Fujichrome Velvia. *Snow falling on this scene created the quiet feeling of winter.*

Below: DENALI NATIONAL PARK, ALASKA. Canon EOS-1n, 28–135mm IS lens, Fujichrome Velvia. *After two days of constant rain and mist, it was great to finally have a break in the storm. The warm afternoon light skimming the surface of the river basin created a pleasant, hopeful mood.*

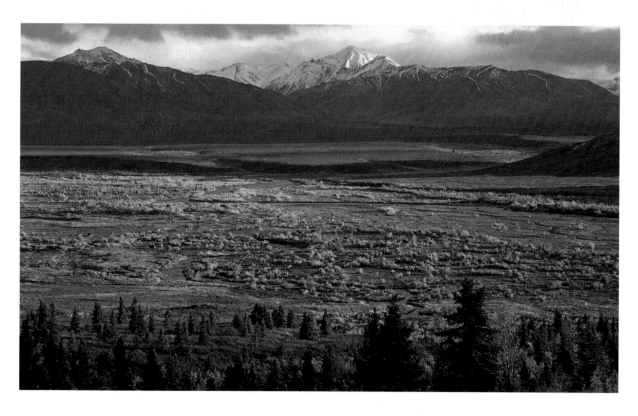

one day. He dipped the pail into the pool and watched, mesmerized, as he poured water out of the pail. He did this repeatedly, expressing a mood of childlike wonder.

Even motion creates mood in a photograph. Fast-paced action creates a mood of excitement. When I was in Washington's Olympic National Park one spring, Sol Duc Falls was flowing with a huge volume of water that roared through the streambed and over the cliffs. The mood was anything but calm, but I slowed down my shutter speed to smooth out the flow and create a relaxing, serene mood.

To capture especially moody images, head outside on stormy, foggy, or snowy days. To evoke a tranquil mood, photograph scenes at twilight. Look for mood every- where around you. Once you learn how to see mood—or even better, how to *feel* it—you can capture the mood of anything.

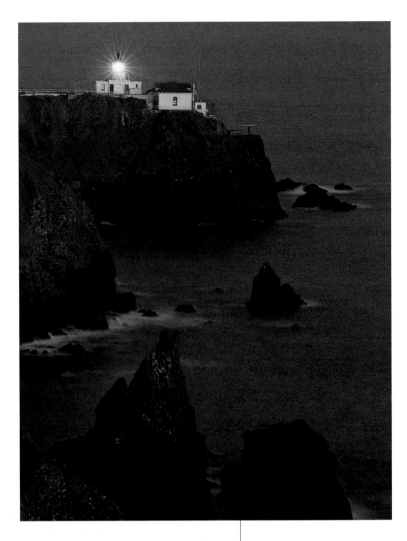

Above: POINT BONITA LIGHT- HOUSE, CALIFORNIA. Canon EOS-1n, 80–200mm, Kodak E100S. *Evening's twilight was a rich blue when I arrived to photograph the lighthouse. A long exposure smoothed out the waves, adding to the ethereal mood of the scene. I timed the exposure so the beacon would be lit, adding a symbolic warmth to the coolness of night.*

Left: CHRISTMAS LIGHTS, CALIFORNIA. Canon EOS-1n, 28–135mm IS lens, Fujichrome Sensia. *My neighbors really deck the halls at Christmas. The warm, colorful glow and the abundance of lights convey a fes- tive, spirited mood. I photographed at twilight to record the deep blue of the sky as a background to the house.*

Above: SLEDDING IN THE SIERRA, CALIFORNIA. Canon EOS-1n, 75–300mm IS, Fujichrome Velvia. *Like a Currier and Ives painting, this photograph is nostalgic, even if you haven't experienced snow or sledding. Falling snow added to the atmospheric mood.*

Left: ELK IN THE MIST, YELLOWSTONE NATIONAL PARK, WYOMING. Canon EOS-1n, 300mm lens, Kodak Ektachrome E100S rated at ISO 160. *The cool, late-September morning was perfect for ground fog conditions, and this young bull stood like a sentinel in the meadow. I pushed the film one stop to add a grainy effect that enhanced the mood of the scene.*

Chapter 8

ARTISTIC
INTERPRE

You get to your creativity by playing. —UNKNOWN

This is the chapter where you get to tell your internal critic to take a hike while you play around with new ideas and experiment with abstraction and impression. Think of your experimentation with the following techniques as a break from the structured kind of photography you may have been doing. You'll have a great time! After a session of play and experimentation, my vision is greatly improved for photographing in more traditional ways. I feel as though I'd rinsed my eyes—everything thing looks different and clearer.

In order to get the most out of this chapter, you should release your need to have perfect results. When you make a photograph that is abstract or an impression, there are no hard-and-fast rules. Yes, there are basic steps you will need to follow to approximate the effect, but that's where the similarity to other types of subject matter ends. Each panned image, every multiple exposure, every slide sandwich will be a one-of-a-kind piece—and therein lies the magic and fun of your experiment! The only limit to your experimentation is your imagination. Your willingness to abandon traditional ideas can expand and enhance your results. While I can't supply rules, here are some of my favorite techniques.

WRAPPED STONES. *This slide-sandwich shows the magic that can happen when you play around with combining images on the light table.*

126

TATIONS

PANNING ON STILLS

Panning on a still scene allows you to blend the elements of the picture into a wonderful abstract of light and color. You can turn an ordinary, static situation into a painterly one. Every panned photograph is a one-of-a-kind original, since you can't create exactly the same effect twice. After experimenting a while with the same subjects at different shutter speeds, you can develop a sense of what works. But there's no formula, and every photograph will surprise and perhaps delight you.

Generally, the fastest shutter speed you'll want to use when panning is around ¹⁄₁₅ second. With a faster speed, you can't complete the pan in time to have the subject streak completely through the frame. Then again, this effect may be perfect for your image! Generally the shutter speeds I choose for panning range between ½ second and 1 second. If you mount your camera on a tripod with a tilt-pan head, you can steady the panning by loosening only one axis at a time. This helps keep streaked lines of light straighter and prevents jagged lines that distract the eye from the main effect of panning. Using a ball head allows for more side movement during a pan.

It takes practice to produce a good image, but it can be done. I prefer to have the movement continue outside the frame edge, which enhances the effect of the panning.

Practice panning on your subject while counting the time the shutter will be open. This gives you a sense of how much movement you might achieve while the shutter is open. You can see why having a slower shutter speed is easier. How can you estimate ¹⁄₃₀ second? Practice runs will give you a sense of whether you're going too fast or too slow. Pan while looking through the viewfinder—you'll see how much area you are covering, which helps you decide on the shutter speed to use.

Above: ASPEN GROVE, NEW MEXICO. Canon EOS 3, 80–200mm lens, Fujichrome Provia 100F. *I vertically panned with the camera mounted on a tripod to abstract the aspens.*

Facing page: SUMMER WILDFLOWER GARDEN, MAINE. Both Canon EOS-1n, 28–135mm IS lens, Fuji-chrome Sensia II. *The photograph at top shows a straightforward image of the garden—not terribly pretty due to the high-contrast light. To express the abstract idea of flowers growing, I panned vertically on the meadow using a ½-second shutter speed. Mounted on a ball head, the pan was not completely straight, resulting in a more organic feeling to the movement.*

ZOOMING THE LENS

Zooming on a still subject during a slow exposure is another way to imply motion. However, a zoom composition always radiates from the center of your frame, so the photograph can become static. To zoom effectively, you need to set the shutter at a speed that is slow enough to record the movement of the lens. If the shutter speed is too fast, you won't be able to do enough zooming. With ISO 100 or slower film, stop the lens down to f/16 or f/22. This allows for a slow enough shutter to create a good zoom effect.

Once you have composed a scene that you like, take a few practice runs on the zoom control to be sure you have your timing down. To get a complete zoom effect, continue zooming through the focal length of the lens, even after the shutter has closed. If you want the streaking in the photograph to be smooth, you need to zoom at a consistent speed. Varying the speed through the zoom will create more wavy effects in the streaks, but this isn't necessarily bad—it all depends on what you want to do. The more you practice, the easier this technique becomes. To experiment further, try zooming and panning at the same time, or zoom on a moving subject instead of a still one.

SPEEDING TREE. Canon EOS-1n, 17–35mm lens, Fujichrome Velvia. *This tree with eleven trunks has "arms" reaching out in all directions. To create the effect of being pulled into those arms, I zoomed during a 1-second exposure. The wide-angle lens exaggerated the effect.*

MAKING MULTIPLE EXPOSURES

A double exposure combines two views of the same subject or two objects that intuitively go together. When I decided that a moonless view of the Seattle skyline at twilight would look better with the moon, I used double exposure to put it into the image. I composed the skyline scene and set the lens at around 85mm to make my first exposure. When the sky became dark and the moon appeared over the skyline, I photographed the moon with my 200mm lens on the same frame, spot-metering it and underexposing slightly so that no extra light would be recorded on the film around the moon. This step ensured that the skyline would remain properly exposed. The moon may not have risen over Seattle that night exactly when and where it appears in my photograph, but its presence certainly adds to the impact of the image.

For double exposures you'll need to underexpose each exposure by one stop so that together they add up to the correct exposure. One factor is critical in making double exposures: Remember where things fall in the composition! On one attempt at a double exposure, I forgot exactly where my moon was in the composition, and I ended up with a beautiful crescent moon sitting on the cables of the Golden Gate Bridge!

You can also create double exposures in which one exposure is in focus and one is out of focus. This creates a halo effect around the sharply focused image, and the results can be dreamlike. Remember to open up to the widest aperture for the out-of-focus exposure; otherwise, it too may be sharply focused.

I've always liked Impressionism. I am fascinated by how a painter can overlap tiny strokes of color onto a canvas to create a wonderful scene with all the light and shading necessary for the viewer to perceive the image. Attempting to create a similar effect in my photography many years ago, I started doing multiple exposures—many photos on one frame. This technique works very well with subjects that have a lot of small detail, such as foliage, gardens, and wildflower meadows. While multiples anywhere in the range of 12 to 64 exposures can create wonderful impressionistic effects, there is no surefire way to ensure you'll get a good image—the only way to get something you like is to keep trying. The good news is that when making 32 exposures on one frame, you don't have to use up a lot of film for your experiment!

Of course, you need to prevent the camera from advancing the film while you are making multiple exposures. Some automatic cameras come with multiple-exposure features. Check the manual to see how many exposures the camera will make. I can set my Canon EOS-1n and EOS-3 for up to nine exposures. When the counter gets down to 1, I turn the dial back up to 9, and do this repeatedly until I have made the number of exposures I want. On some older cameras, you can push in a "clutch" release button so the film

lever trips the shutter but doesn't advance the film.

An important note: Even if your camera can do multiple exposures, the camera meter does not adjust accordingly. You must determine the correct setting for each exposure you make. Here's how: Decide how many exposures you want to make. Then multiply the ISO of the film you are using by the number of exposures. For example, if you want to make 12 exposures and you are using ISO 50 film, your number is 600. Set your ISO dial to this number. You have now tricked the camera into thinking it has faster film, so the meter will reduce the light proportionately to $\frac{1}{12}$ of the total light needed. Once you make all 12 exposures at this reading, you have a correctly exposed image—theoretically.

If your image needs a little extra exposure, adjust the ISO at the beginning of the calculation. For example, if you are using 50 ISO film and you want to go a $\frac{1}{3}$ stop over on the exposure, change your ISO to 40. Multiply that by the 12 exposures you want to make; this gives you 480. You can also adjust your exposure by increasing or decreasing the number of exposures you make, but that alters the effect of the overlap.

Now the fun begins. While handholding the camera, choose a composition you like and find an object or area you can use as a homing point. Move the camera slightly around the homing point each time you shoot, but don't move the camera so much that you detract from the overlapping effect. The higher the number of exposures you make, the more you can overlap elements. There isn't any right or wrong way to do this; you just get a different effect each time, and some may please you and others won't. Remember to watch for any bright or dark areas, which won't go away in a multiple exposure.

WILDFLOWER MEADOW, COLORADO. Nikon FE2, hand-held, 85mm lens, Kodachrome PKR 64. *I made 32 exposures on one frame of this wildflower meadow to create a stippled effect similar to that of an Impressionist painting.*

SANDWICHING YOUR IMAGES

This technique has been around for a long time, and photographers have used it to make some great interpretive photographs. The computer can achieve this technique for us easily now, but I still like to sandwich the traditional way. The choice of images you can put together is limited only by your imagination. We've all seen super-large moons combined with normal-sized landscapes or a rainbow overlaid on a stormy scene. When you try sandwiching, you might want to make sure that you won't offend anyone with your altered view of reality. I sometimes see larger-than-life moons in images published by environmental organizations, which usually stick with reality, and I wonder how their readers might react.

Sandwiching adds density, so you must overexpose each image by one stop. If you plan to combine more than two images, you need to overexpose each of them so that the total exposure adds up to a correctly exposed picture. I often sandwich slides after the fact—sometimes just because I happen to like the effect of two slides overlapping on my light table—so I have them duplicated or scanned with increased exposure to lighten the final image.

MIGRATING BIRDS AND MOON, CALIFORNIA. Camera equipment varied for each image. Fujichrome 100. *To capture my interpretation of bird migration, which often takes place at night by the light of the moon, I made a sandwich of two transparencies that combined a twilight image of the moon and hillside with one of the birds in flight made in the daylight.*

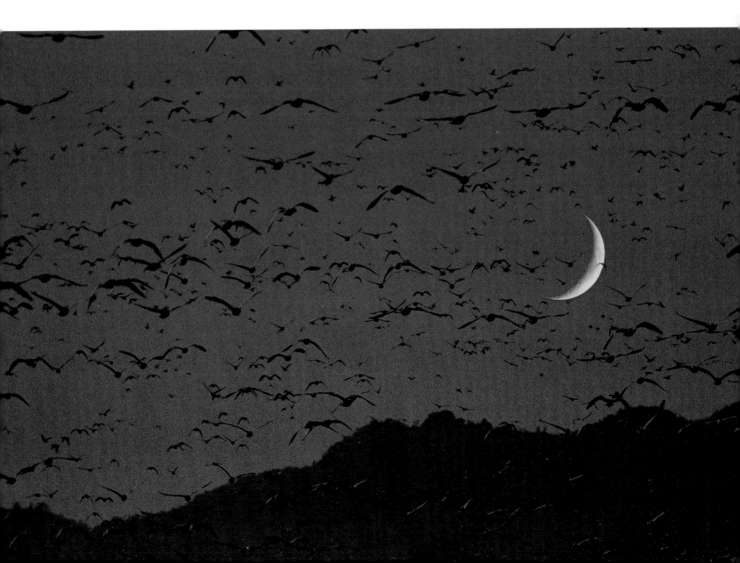

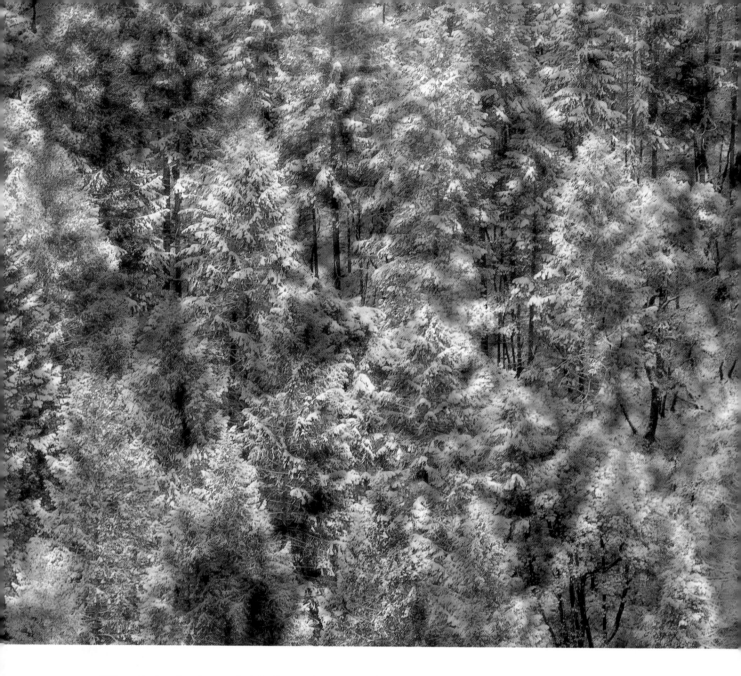

When I plan for the sandwiched effect, I think about textures overlaying whole scenes, such as sand grains creating texture for an image of a fishing village. I sometimes expose an entire roll of film on sand dune patterns and textures, and overexpose all of them, so I can sandwich them at will. My favorite way to slide-sandwich is to create one slide in focus and one out of focus, then put the images together. You can create unusual, dreamlike effects with this method. As you combine the out-of-focus image with the focused image, halos of color surround the sharper areas of the picture, creating an ethereal effect. To achieve this effect, I make several in-focus frames, overexposing by 2, 2½, and 3 stops, and several out-of-focus frames, overexposing by ½, 1, and 1½ stops. To ensure that the out-of-focus image stays that way, remember to set your lens to its widest aperture. When you defocus the lens, focus closer so the image gets larger. You may have to adjust your composition so that the main objects are still overlaying each other; otherwise, you will achieve more of a zoom effect.

WINTER DREAMS. Canon EOS-1n, 80–200mm lens, Fujichrome Velvia. *I sandwiched two slides to create the ethereal effect of snow-covered trees. One of the images is in focus, one is out of focus, and both are overexposed.*

SHOOTING THROUGH OTHER OBJECTS

How does a ground squirrel see the meadow as it focuses on a delicious-looking blossom just a few feet away? You can show this view by focusing on one flower in the meadow and putting another flower or group of leaves up close to the lens. The leaves or flowers close to the lens will be out of focus, which transforms them into transparent washes of color and soft shapes that surround the in-focus subject. When we view a photograph made with this approach we are *in* the scene, rather than outside looking into it.

To try this interpretive technique, use a lens in the 200–300mm range, and position yourself so that one or two blossoms or a cluster of leaves are very close to the lens. Focus through them to your subject, keeping the aperture wide open so that only your subject is sharp. The challenge is to find the right conditions, because the two groups of flowers must be a certain distance apart for the effect to be evident. The planes of focus must stay separate, and you really want only your subject to appear sharp. Using this technique, you can play with color contrasts and harmonies with the out-of-focus colors. A good time to experiment with this technique is on a windy day when you can't make the other images you want, since your wide-open aperture will mean you can use a faster shutter speed.

WILD POPPIES, ARIZONA. Canon EOS 3, hand-held, 80–200mm lens with 25mm extension tube, Fujichrome Velvia. *To produce a dream-like effect, I created a wash of lavender and magenta hues over and around the orange poppies by focusing through the blossoms in the foreground.*

EXERCISING YOUR
VISION

Once the mind has been stretched by a new idea, it will never again
return to its original size —OLIVER WENDELL HOLMES

W riters can suffer from writer's block, and
photographers can become visually blocked.
I've had it happen. I arrive some place and think to
myself, "Why bother? So-and-so has a great shot of
this already, and I've seen a dozen similar images of
this scene."

I've had days when I've had lots on my mind, and I can't see
a creative atom anywhere near me. When this happens, I try to
start photographing without analyzing the pictures I am making.
I consider these photos to be part of a warm-up exercise, and
before I know it my eyes and mind are primed and ready to see
again. The following exercises are designed to help get your cre-
ative juices flowing, to stimulate your mind and your eyes.

- Expose an entire roll (36 exposures only!) on one object, from
 every angle and point of view you can find.
- Photograph concepts, metaphors, and contrasts. Here are a
 few to get you started: standing out from the crowd, cheerful-
 ness, solitude, exuberance, stretching, death and rebirth, light
 and heavy, cold and hot, fast and slow.
- Use your wide-angle lens to make close-ups.
- Use your telephoto lens to make landscapes.
- Select a three-by-three-foot area and expose at least one roll
 within that area—and don't look outside the perimeter.
- Try to illustrate a dream you've had.

SAGUARO CACTUS, ARIZONA. Canon EOS-1n, 28–135mm IS lens, Fujichrome
Velvia. *One month I gave myself the assignment of photographing things I found*
funny. This was just one of many hilarious things I found.

- Photograph for an entire day from the standing height of a two-year-old child.
- Photograph for an entire day looking up at everything.
- Photograph something or somewhere you've never photographed before.
- Photograph reflections.

- Make a black-and-white image on color film (de-emphasize the color in the picture).
- Get into a meadow and photograph everything with the lens aperture wide open.
- Expose an entire roll creatively out of focus.
- If you always photograph in

Above: CHEERFUL SUN-
FLOWER, ITALY. Canon EOS-
1n, hand-held, 20–35mm
lens, Fujichrome Velvia.
*Attempting to photograph the
concept of cheerfulness, I came
upon this sunflower in a meadow
in Tuscany.*

Left: LEAVES AND SAND-
STONE, ZION NATIONAL
PARK, UTAH. Canon EOS-3,
28–135mm lens, Fujichrome
Velvia. *Rain and wind took
down the last of the autumn
leaves, scattering them along this
sandstone wall of a wash near
Checkerboard Mesa.*

macro, spend a week using your wide-angle lens.

- If you always use your wide-angle, spend a week using your telephoto lens.
- If you always photograph wildlife, photograph people.
- Tell a story about a nearby park, village, or refuge in four pic-

tures. (Make only four pictures for this one—make each one count).

- Pick a familiar object and photograph what it means to you.
- Pick an unfamiliar object and photograph what it means to you.

EVALUATING YOUR
PROGRESS

Don't evaluate the pictures you thought you made, evaluate the ones you actually made. —FREEMAN PATTERSON

When it comes time to review film in my workshops, the groans from students are audible. It's not their favorite time of the class, but it *is* mine because someone invariably shows me a new way of seeing. It's that eye-opening experience that makes film-review sessions so wonderful.

If you want honest evaluations from other sources, don't ask Mom or family members! Almost everyone I know has heard, "You should make calendars with these images," or, "You should try to get these published" from a family member, who looks at your pictures through "love-coated" filters. If you want a more unbiased evaluation, hire a professional or take a one-day critique class with a local instructor. Find someone whose work you respect and like, so that you'll openly accept and trust their opinions.

At some point, you'll have to learn how to critique your own work to assess your progress. The key to this is learning how to move away from the emotional connection you have with your pictures. Never mind that it took four hours to climb the hill for a unique viewpoint of the village or that you bushwhacked your way through sedges and 12 inches of water to capture a Great Blue Heron eating a fish. We've all done hard things to make a picture. Does the photograph work? It's still the fundamental question, and you answer it by asking several other important questions. After you've put aside the obvious "woofers" from your most recent group of photographs, use a checklist of questions to help you evaluate the rest.

ZINNIA BOUQUET. Canon EOS A2, 26–70mm lens, Kodak Ektachrome E100S.

Once you have decided the image works, congratulations are in order! But what if it doesn't work? Don't toss out that image just yet. With digital image-editing, you can save some images. You can't solve poor lighting, focus, or perspective problems, but you can crop, adjust the color, eliminate the telephone pole in the middle of the picture, and correct for other less serious problems. I've photographed scenes that I would have avoided before the era of computer image-editing. Once, having just broken my 2-stop graduated filter, I knew I wasn't going to be able to record both sky and land on a rocky beach in Acadia National Park. But I just had to have that image at sunrise: I had gotten up very early to get there, and it was a beautiful moment. I made two exposures— one for the land, one for the sky— and with the computer I could put them together. It's nice to know that the digital option is there.

It's a known fact that the photographs we make grow more dramatic while they're away at the lab, so that when they finally arrive on our light table, they can be disappointing to view, given all the expectations we've built up around them. A friend working for *National Geographic* used to tell me he was frequently disappointed when he got the film back from the lab, but after the first edit for obvious errors, he would put the rest aside for a day or two, then look at them again. When your memory of the experience of making the photograph recedes, you can look at the image more objectively.

Facing page: MONTICIELLO, ITALY. Canon EOS-3, 28–135mm IS lens, Fujichrome Velvia. *The gentle S-formation of the pathway up the stairs provides the main line around which I built my image, which culminates with the door at the top. There is visual tension here because you travel to the door and it's closed. If the door were open, you would move out of the scene into a dark space.*

SELF-EVALUATION CHECKLIST:

Begin with this list and add your own questions that may be specifically appropriate to what you like to photograph—say, for underwater or aerial photography. Be ruthlessly honest, but also realize that while you may not have gotten the image you wanted, perhaps you made a better one.

- Does the photograph express your intent?
- Is the light right for the subject or situation you are photographing?
- Does the photograph make use of any existing design elements?
- Does the picture make good use of perspective to create visual interest?
- Is the image composed well, the arrangement dynamic?

- Are the exposure, focus, and other settings correct or appropriate for the subject?
- Could the photograph have been simplified with less clutter?
- Is there something in the image that detracts from the main focus, something you should have left out?
- Is the photograph excellent from an all-around technical point of view?
- Does the photograph evoke an emotional response when you look at it? Was it the emotion you intended?
- Do the color relationships work?
- Did you capture the moment or gesture successfully (if there was one)?

Chapter 11

A DEEPER
VIEW

The question is not what you look at, but what you see.
—HENRY D. THOREAU

You can photograph a flower, but can you capture its personality? More important, do you think a flower has a personality? Do you see spirits in rocks, faces in snow banks? Is a calla lily sensual to you? When you look at something, what you see depends upon how open your soul's "eyes" are. The more open you are, the more deeply you can see from an emotional point of view. If you want to photograph more creatively, let go of your tendencies to define things, and look more closely at what is there, not just what you think is there. Think metaphorically. Is the dew-covered spiderweb nature's own necklace of jewels?

In the first chapter of this book, I suggested asking yourself what you are trying to say with the photograph. Now take it a step further and think about what the subject is saying to you. The image that results from what you see in your mind's eye can have more impact than a technically good record photograph.

REDBUD BLOSSOMS AND OLD SEEDPOD, SEQUOIA NATIONAL PARK, CALIFORNIA. Canon EOS-1n, 90mm tilt-shift lens, Kodak E100VS.

A CLOSER LOOK

The intimate world of nature is full of little gifts to unwrap. Even with all the drama of the big vista, I'm often brought to my knees by the detail right in front of me. Thousands of details make up the larger scene, yet often the grand vista overwhelms the details. Once while I was leading a photo tour in Utah, a participant who was interested only in the big landscape asked to see a macro image my co-leader had composed. "Hmmm," he said, "that's nice." He wandered off for a while, and when he returned, the co-leader was making a new macro image. Asking for another peek, this time he said, "That's art!" With that, he disappeared behind a dune. An hour later, when it came time to leave, we asked his wife where he was, and she replied, "Out in the dunes on his hands and knees doing macro photography!"

Close-up photography is just a closer view of something, so you can use everything from a macro to a telephoto lens. I've used a 28–135mm lens to fill the frame with the colorful detail of Alaska's tundra plants. I've used a 100mm macro lens to photograph a tiny hummingbird nest with eggs, working quickly to let "Mom" return to the nest. To capture the luminescent details of an iceberg, I've used an 80–200mm lens at various focal lengths. Each situation requires a different combination of equipment designed to give you the amount of closeness you need for your photograph. The following are my two favorite close-up tools:

Close-up lenses, also called diopters, look like filters, but these magnifying lenses allow a regular lens to focus closer. They also increase magnification when you use them with your standard macro lens. Because no light is lost through these filters, they offer the most flexibility for making close-up images. Top-quality, dual-element diopters are sold individually and

CALIFORNIA POPPY, CALIFORNIA. Canon EOS-1n, 100mm macro lens, Fuji-chrome Velvia. *I felt that all the poppies in this field had unique personalities and this one was the jauntiest of them all.*

Left: GULL FEATHER AND RAINDROPS, ALASKA. Canon EOS-1n, 100mm macro lens, Fujichrome Velvia. *We happened upon a meadow with gull feathers scattered from a preening session, and the night's rain had covered them with jewel-like raindrops.*

Below: CHOLLA SKELETON AND BLAZING STARS, ORGAN PIPE NATIONAL MONUMENT, ARIZONA. Canon EOS-1n, 100mm macro lens, Fujichrome Velvia. *This portrayal of the idea of death and rebirth creates a strong visual statement of contrast, just what life in a desert environment is all about.*

come in specific diameters; most fit lenses with a 62–72mm filter size.

Extension tubes contain no optical glass; they just push the lens farther away from the film plane and, in so doing, increase the magnification of the image. The downside of extension tubes is that you lose light with them, so in even the slightest breeze, you'll have some trouble trying to keep the image sharp. The upside is that you can use them with many of your lenses. I can put my 12mm EF tube on my 20–35mm or 300mm lenses.

The overall goal in photographing the world close up is to share with others details they might have missed. Yet there are many different approaches to macro photography. Some photographers like to photograph intimate landscapes, while others want to get close enough to see whether the bug is carrying any luggage! Some prefer everything exposed at f/22, while others leave their lenses wide open. The choice is totally personal, and it all boils down to that now-familiar question: What you do want to say with your photograph?

Many books have been written on techniques and equipment for close-up photography. I recommend reading John Shaw's *Close-Ups in Nature* for in-depth how-to information. If you haven't mastered the technical aspects of close-up photography yet, you can still learn to see the close-up world more creatively. Think in terms of interpreting your subject instead of merely recording it.

- Is the scene a contrast of death and rebirth?
- Is the image a detail of a hillside or an abstract canvas?

FINDING THE ESSENCE

Left: AUTUMN CHAIRS, VER-
MONT. Canon EOS-1n, hand-
held, 28–70mm lens,
Fujichrome Provia. *Here's one
take on the essence of autumn.
The scattered leaves suggest these
chairs have been abandoned until
next year.*

Below: REFLECTIONS, BODIE,
CALIFORNIA. Canon EOS-1n,
28–135mm IS lens, Fuji-
chrome Sensia. *The tattered
curtain, weathered window frame,
and sagging shack add up to the
essence of abandonment.*

What is the essence of a tree or of water? Can essence be photographed? According to the dictionary, essence is "that which makes something what it is." So if we learn to look deeply enough, we can photograph what makes a tree a tree. For example, there are things that are specific to certain trees. The essence of a California oak tree might be its gnarled branches or the way they stretch out from the tree. A birch tree's essence might be the papery, peeling bark.

Essence is sometimes difficult to put into words, but we intuitively recognize it in some things, and so we can photograph them from that perspective. When someone tells you that you've captured the essence of something in a picture, you've succeeded in expressing an idea that is widely felt or understood. At other times, the essence may simply be what *you* consider it to be.

First, ask yourself what the idea or object means to you. For example, what is the essence of autumn? What elements define that essence? For example, it might be pumpkins, or autumn leaves, or geese flying in formation. If, for you, the essence of autumn involves colorful leaves, how can you photograph those leaves so that they express that? Do you want them sharply focused and crisp, like the autumn air that surrounds them? Or should they appear as soft, blurry impressions in which the colors overlap and blend to create a palette of autumn hues? The choices are yours to make.

Everything has an essence, but to find it you'll need to open up your mind and throw out your need to be literal. To stimulate your mind and eye to think about essence, try photographing images that express:

- Death
- A season
- A flower
- Water
- A rock
- A snake
- The West (beyond the obvious cowboy image)
- The desert
- The forest
- A parade
- A feast day
- A place: a wilderness area, state, county, or village

This is just a short list of ideas, but they can help jump-start you on the path to discovering the essence you see—in everything. Once you get started, you may find your list goes on forever! Whatever you do, take some time to find the essence of things. There is magic in the discovery of it.

DOGWOOD AND MERCED RIVER, CALIFORNIA. Canon EOS-1n, 80–200mm lens, Fujichrome Velvia. *This image captures the essence of renewal and spring. It has a peaceful feeling to it—even though I was perched precariously on a steep bank over the water with a tripod.*

THE MAGIC OF WATER

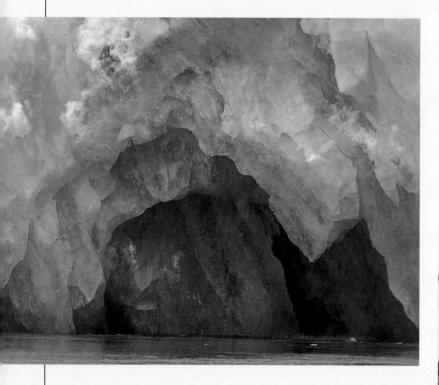

The late science writer Loren Eisley once said, "If there is magic on this planet, it is contained in water." I have never found a more appropriate way to describe my own feelings for water. Translucent and reflective, solid and liquid, ice or snow, water is mysterious and beautiful. I am constantly drawn to water as I try to capture its essence in photographs.

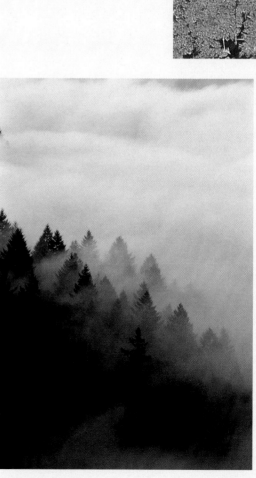

BEING OPEN TO THE WORLD
AROUND YOU

You are open when you are willing to look at what is presented to you, and when you respond to it and do not analyze it.

When was the last time you picked up your camera and headed out the door with no specific plan or destination in mind? If it wasn't recently, it's time to get out there! It's great to go out without a specific plan and see what presents itself. A walk to the local park might provide you with all the photo possibilities you can handle in a day. For that matter, a walk into your backyard could do the same thing. It depends upon your openness to what's around you.

When I plan a photo trip, I research the places I want to go and list the photographs I hope to make.

This research allows me to capitalize on my time in the field so I can also have time to wander and be more receptive to what the place has to show me. I've made some of my best photographs—and had some incredible experiences—when I didn't have a plan for where I wanted to go.

Sometimes being open means being flexible about a plan you might have. When my partner and I visited Monte Verde Cloud Forest in Costa Rica, our first trip to a rainforest, we were told it would take only one and a half to two hours to walk a one-mile loop. Four hours later, we had only gone a quarter of a mile! From the moment we ducked in under the canopy, we discovered fascinating things under every leaf and log and around and in every tree.

Facing page: RAINY DAY CYCLIST, CALIFORNIA. Canon EOS-1n, 80–200mm lens, Fujichrome 100. *I stood outside the driver's side of my car in the rain and focused on the inside of the passenger window. I deliberately put the background out of focus to soften it, still allowing it to read clearly. Then I waited for a cyclist, never imagining I'd get someone clad in such wonderful color.*

Below: MUD PATTERNS, MOJAVE DESERT. Canon EOS-1n, 100mm macro lens, Fujichrome Velvia. *Keep an open mind and you can find photographs anywhere, even in a drying mud puddle.*

A wise person once said, "Beauty is in the eye of the beholder." Once, while in Yellowstone photographing with a group in a grove of trees, a man ran over to us excitedly with his camera and asked, "What are you seeing?" My partner answered, "Trees." The man looked at him in disbelief, then shrugged as he walked off. "Trees!" he muttered, as if we were nuts. I guess he had hoped for a moose. Perhaps if the man had been open to more than just "trophy hunting," he might have seen the beauty that we saw in that simple grove of trees.

The most important things that a photographer should carry are his or her feelings and emotions, because you make a great picture with your soul, not your eyes. You can't make images that affect others if you aren't in some way affected while making them.

WESTERN GREBE, CALIFORNIA. Canon EOS-1n, 300mm lens, Kodak E100S. *I wasn't able to capture the impact of an oil spill until I saw this beached grebe desperately attempting to clean oil from its feathers. I felt the connection— the effect of the spill on a living, breathing creature.*

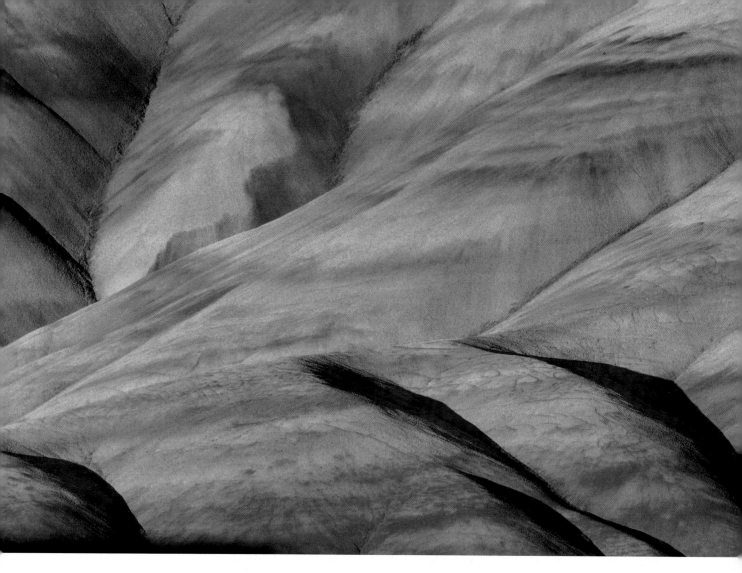

DISCOVERING YOUR PERSONAL STYLE

I am always amazed by the variety of images produced when eight people photograph the same subject or idea, or even the same scene. Everyone has a unique way of seeing the world, and most of us want to be recognized or remembered for that vision, that expression we call our work. When I am reviewing the portfolios of students, they often ask, "Do you see any style to my work?" It's a valid question.

Your photography may already have a style. To find out, gather a large collection of your prints or slides and analyze them carefully. Find the common factors in the photographs. Do you gravitate toward close-ups or landscapes? Are your landscapes only of natural subjects, or do you photograph scenics that include manmade objects? Do you use your wide-angle or your telephoto lens more often? Do your photographs portray a message? If so, is there a common message underlying your work?

Make a list of characteristics that stand out to you. Ask someone you trust if they see a common denominator in your photographs. The process will also help you discover favorite techniques, viewpoints, colors, or subjects. You'll see where you've been and perhaps where you're going with your vision.

PAINTED HILLS, OREGON. Canon EOS-1n, 300mm lens, with 1.4 teleconverter, Fujichrome Velvia. *I love the painted colors of these sedimentary hills that are part of the John Day Fossil Beds. By extracting a small section of the hillside with my telephoto lens, I was able to abstract the hills to look like a painting—to me this captures their essence.*

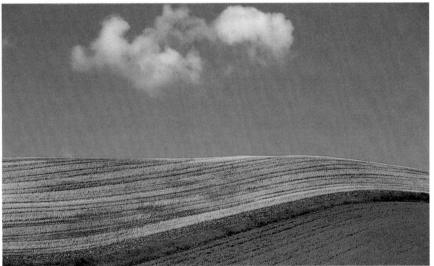

Style evolves from constant self-expression. It's who you are, a combination of your emotions, experiences, and knowledge. You can't force style. If you are too intense about creating a "look" to your work, you may be seriously limiting your vision and your creativity. Loosen up and photograph what you love—with all the passion, artistry, and technical skill you can muster. Make many photographs, evaluate them, and study the masters whose work you admire. In time, your personal style will become evident. You are original, and your vision will express that. Stay true to it.

WHERE TO GO FROM HERE

If I've done a good job with this book, you are sitting at the edge of your seat ready to hit the fields and forests and villages and coastlines to make new photographs. All the ideas in this book will help you, but the most important factor is your imagination. If you stretch your mind, ask that "what if" question, and then act upon your curiosity, you'll find an endless supply of things to photograph. If you dig deeper into your own feelings about what you love to photograph, you'll find the emotional connection that may be missing in your images.

What comes next? If you are like many people I know, making photographs is good enough. They share their photographs with friends and family, and maybe a few images hang on the walls of their homes or offices. Many also belong to camera clubs and share their work with fellow enthusiasts. I've judged at these clubs, and the real meaning of amateur, *for the love of something,* rings true. These people are motivated by their love of the craft. It inspires me to see the work these people produce.

If you plan to make photographs as a hobby, you can still get your work out there to be seen and enjoyed by others. You can:

- Participate in exhibits.
- Give local slide shows. Many active adult communities and retirement homes eagerly welcome people who volunteer to entertain their residents.
- Make your own greeting cards.
- Donate your work to worthy

nonprofit causes. Even though many large organizations hire professionals, most, especially smaller ones, don't have money in the budget for photography.
- Develop personal projects. I have an ongoing project to photograph trees. Think of your idea as a collection of impressions from the place or of the subject. It gives you something to plan for, to build on, and to be challenged by as you think of more ways to interpret your subject.

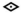

If you let yourself see the world as a child sees it, full of wonder, you'll begin to see the world in new ways. Apply the concept of light and the ideas of design, composition, and perspective to your images. Try the other techniques as they fit with your personal interests. You are limited only by your imagination, so stretch, develop your vision and skills, and you'll become a better photographer.

DOUGLAS IRIS, NORTHERN CALIFORNIA. Canon EOS-1n, 100mm macro lens, Fuji-chrome Velvia. *The royal purple set against a background of fresh green just shouted, "Spring!" I focused on just a few dewdrops and kept the aperture on the lens wide open.*

TOOLS AND RESOURCES

WHAT'S IN THE BAG

I've developed basic checklists that I use when preparing to go into the field. After a few experiences of arriving at destinations without some necessary piece of equipment, I learned my lesson! I frequently have to move gear from one bag to another for a particular assignment, so having a checklist has saved me on numerous occasions.

I use Canon equipment for my 35mm system, because it's great for what I want to do and it feels right in my hands. Here's what I carry in my bag when I don't have to travel too far:

- *Cameras:* Two identical camera bodies, either the EOS-1n or the EOS 3, one with a power booster.
- *Lenses and extenders:* A 20–35mm f/2.8, a 28–135mm IS, a 24mm f/2.8 tilt-shift, a 90mm f/2.8 tilt-shift, a 300mm f/4 or a 100-400mm IS, a 1.4 extender, and two extension tubes or a diopter. If I am going to do macro work, I add the 100mm macro, but I often use the 90mm tilt-shift or the 80–200mm with an EF25 extension tube.
- *Flash equipment:* 550 EX flash, off-camera flash cord, Sto-Fen Omni Bounce diffusion dome and the Flash X-tender, and a folding flash concentrator with fresnel lens.

- *Filters:* A set of three graduated ND filters, a series of warming filters, circular polarizing filters, and a few special-effect filters.
- A 32" fold-up diffusion disc and a soft gold/white reflector.
- Model/property release forms on index cards.
- Macro kit (paintbrush, hair clips, fishing line), and the Plamp® (see the resources list).
- Spare batteries, lens-cleaning cloth, eyeglass repair kit (to tighten lens screws that come loose).
- Marker pens, film labels, colored stickers.
- Swiss army knife or Leatherman Wave®.
- Headlamp and mini maglight.
- Small notebook, pen, and mini-recorder.
- Sunblock, water bottle, mini first-aid kit

If I have to travel light or keep the bag smaller, I have a list for a minimum amount of gear that fits in the Lowe's Street and Field shoulder bag or the Alpine Rover Lite backpack, plus some modular pouches on the belts:

- One camera body.
- 20–35mm f/2.8 lens, 28–135mm f/3.5–5.6 IS lens, 75–300mm f/4–5.6 IS lens.
- Warming and polarizing filters, diopter, remote release for camera, and flash with Omni-Bounce diffusion and off-camera cord.
- Permanent marker, film labels, lens-cleaning cloth, eyeglass repair kit, spare batteries.

I use a Gitzo G1228 carbon-fiber tripod or a Bogen 3221 tripod, and a Bogen monopod. I use an Arca Swiss B-1 ball head. For mounting my 500mm, I use the Wimberley Sidekick, a necessity for working with longer lenses. I sometimes pack a tabletop tripod.

RESOURCES

AGFA CORPORATION.
www.agfa.com.
Tel: 800-879-2432.
Makers of Scala, a black-and-white slide film, along with a range of print and chrome films and printing papers.

ANNE LAIRD & ASSOCIATES.
P.O. Box 1250, Red Lodge, Montana 59068.
Tel: 406-446-2168.
Makers of tripod leg covers, rainhoods for lenses and cameras, and water-resistant groundcloths.

BOGEN.
www.bogenphoto.com.
Tel: 201-818-9500.
Makes tripods and heads, super-clamps, magic arms, and brackets. Also represents the Gitzo line of tripods and heads.

CANON USA.
www.canon.com.
Tel: 800-652-2666.
Makes great cameras, lenses, flashes, and digital and video cameras.

EASTMAN KODAK CO.
www.kodak.com.
Tel: 800-242-2424.
Manufacturers of E100S, SW, and E100VS film.

FUJI PHOTO FILM, USA.
www.fujifilm.com.
Tel: 800-800-3854.
Manufacturers of Velvia and Provia 100F and 400F.

LOWEPRO U.S.A.
www.lowpro.com.
Tel: 707-575-4363.
Makes durable, well-designed backpacks and carrying systems for photography gear.

PELICAN PRODUCTS.
www.pelican.com.
Tel: 310-326-4700.
Makers of great waterproof, airtight cases for equipment storage and protection.

PHOTOFLEX, INC.
www.photo flex.com.
Tel: 800-486-2674.
Makes reflector and diffusion discs, panels, softboxes, and more.

REALLY RIGHT STUFF.
www.really-rightstuff.com.
Tel: 888-777-5557.
Superbly machined quick-release plates for lenses and cameras, flash brackets, and other mounting accessories.

LEONARD RUE ENTERPRISES, INC.
(L.L. Rue). www.rue.com.
Tel (orders only): 800-734-2568.
You name it, they have it, for the nature and wildlife photographer.

SINGH-RAY FILTERS.
www.singh-ray.com.
Tel: 800-486-5501.
Makes great graduated neutral density filters. Superb warming polarizing filters, and enhancers.

STO-FEN.
www.stofen.com.
Tel (orders only): 800-538-0730.
Makes the Omni-Bounce flash diffusion boxes, customized for your flash head.

TIFFEN MANUFACTURING CO.
www.tiffen.com.
Tel: 800-645-2522.
Makes filters; distributes Domke bags.

VISUAL DEPARTURES, LTD.
www.visualdepartures.com.
Tel: 800-628-2003.
Makes great Flexfill diffusion and reflector discs, other assorted products.

WIMBERLEY.
www.tripodhead.com.
Tel: 540-665-2744.
Manufacturers of the fantastic gimbal-type tripod heads for long lenses. Also produces the Plamp, a bracket for stabilizing plants, as well as flash brackets.

SUGGESTED READING

Boice, Judith. *Mother Earth.* Sierra Club (now Univ. of California Press). *Beautiful compilations of essays and poems by women writers with images by women photographers.*

Brandenburg, Jim. *Chased by the Light.* Creative Publishing International. *This wonderful book documents a season, one photograph per day.*

Burian, Peter. *National Geographic Photography Field Guide.* National Geographic Society. *An illustrated guide covering a wide selection of how-to topics.*

Lepp, George. *Beyond the Basics (I and II):* Lepp & Associates. *Highly informative books on all sorts of techiques for nature photography.*

Neill, William. *By Nature's Design.* Chronicle Books. *A captivating look at the presence of design in the natural world.*

Patterson, Freeman. *Photographing the World Around You; Photo Impressionism and the Subjective Image;* and many others. Key Porter Books. *These books cover design, composition, and color and present alternative techniques for expressing ideas.*

Peterson, Bryan F. *Understanding Exposure; Photographing People;* and *Learning to See Creatively.* Amphoto. *These well-written books cover everything you need to "get it right" on film, no matter what your subject.*

Powning, Beth. *Home.* Stewart, Tabori and Chang. *This wonderful book, beautifully written and accompanied by artistic photographs, is a diary of twenty-five years of living in the country in New Brunswick, Canada.*

Shaw, John. *Close-ups in Nature and Nature Photography Field Guide.* Amphoto. *These books are filled with technical information on techniques and equipment.*

INDEX

Abell, Sam, 16, 44
Artistic interpretations, 126–135

Backlight, 28–29
Balance, 83–85
Being open to world, 152–154
Blue, 100, 101, 102
Brightness, subject, compensation for, 43
Broughton, James, 6

Capturing gesture, 112–114
Cartier-Bresson, Henri, 73, 106
Celebrating moments, 108–109
Close-up lenses, 146–147
Color, 98–105
 of light, 32–33
 properties of, 100–102
Color harmony, 103–105
Compensation, for subject brightness, 43
Composition checklist, 93
Composition formula, 79
Compositions, 76–97
Curving lines, 52

Dawn, light of, 30–31
Deeper view, 144–157
Depth, selective focus and, 66
Design, visual, 44–61
Diagonal lines, 50, 51
Direction, of light, 26–29
Dominance, 80–81, 82
Dynamic image, 62–75

Eisley, Loren, 150
Essay, photo, 110–111, 150–151
Essence, finding of, 148–149
Evaluation
 of exposure, 43
 of progress, 140–143
Exercising vision, 136–139
Exposure(s)
 evaluation of, 43
 multiple, 131–132
Expressive techniques, 106–125
Extension tubes, 147

Fill-flash, 42–43
Film, seeing of light by, 20–21
Filters, 34–41
Flash, fill-, 42–43
Flow, going with, 117–118
FL-W filters, 38, 40, 41
Focus, selective, and depth, 66
Form, 55

Frame, importance of, 92–93
Freeze frame, 116
Frontlight, 26, 28

Gesture, capturing of, 112–114
Going with the flow, 117–118
Graduated neutral density (ND) filters, 36–38
Green, 100, 101

Haas, Ernst, 73, 98
Harmony, color, 103–105
Holmes, Oliver Wendell, 136
Horizontal frame, 92–93
Horizontal lines, 46–48

Image(s)
 dynamic, 62–75
 sandwiching of, 133–134
Interpretations, artistic, 126–135

Jones, Dewitt, 14

Learning to see, 12–15
Lenses, 69–75, 146–147
 zooming of, 130
Less is more, 91–92
Light, 16–43
 color of, 32–33
 of dawn, 30–31
 direction of, 26–29
 modifying of, with filters, 34–41
 natural, 21–25
 seeing of, by film, 20–21
Line, 46–52
Looking closer, 146–147

The Magic of Water, 150–151
Modifying light, with filters, 34–41
Moments, celebrating of, 108–109
Mood, expressing of, 123–125
Motion, expressing of, 115
Multiple exposures, 131–132

Natural light, 21–25
Neutral density (ND) filters, 36–38
Normal lenses, 73

Openness, to world, 152–154
Orange, 100–101

Panning
 and motion, 119–121
 on stills, 128–129
Pattern, 56–58
Patterson, Freeman, 140
Personal style, 155–156

Perspective, 64–65
Photo essay, 110–111, 150–151
Point of view, 67–68
Polarizing filters, 34, 36, 38, 39
Progress, evaluation of, 140–143
Properties, of color, 1001–02
Proportion, 86–87
Proust, Marcel, 12
The Pumpkin Patch, 110–111
Purple, 100

Red, 100, 101–102
Rhythm, 96–97

Sandwiching images, 133–134
Scale, 88–89
Secondary colors, 100–101
Seeing, 12–15
 by lenses, 69–75
 of light, by film, 20–21
Selective focus, and depth, 66
Self-evaluation checklist, 143
Shape, 53–54
Sharing your work, 157
Shaw, John, 147
Shooting through other objects, 135
Sidelight, 26, 27, 28
Simplification, 90–91
Situation, working of, 94–95
Stills, panning on, 128–129
Style, personal, 155–156
Subject brightness, compensation for, 43

Techniques, expressive, 106–125
Telephoto lenses, 74–75
Texture, 59–61
Thoreau, Henry D., 144

Vertical frame, 92–93
Vertical lines, 48, 49
View, deeper, 144–157
Vision, exercising of, 136–139
Visual design, 44–61

Warming filters, 34, 35, 38, 39
Water, 150–151
Weston, Edward, 76
Wide-angle lenses, 69–71, 73
Working the situation, 94–95
World, being open to, 152–154

Yellow, 100, 102

Zooming, of lens, 130